IMAGES
of America

FIRE ISLAND
BEACH RESORT AND
NATIONAL SEASHORE

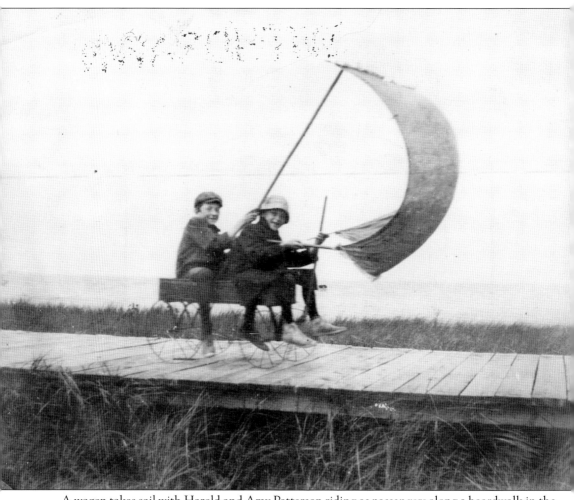

A wagon takes sail with Harold and Amy Patterson riding as passengers along a boardwalk in the community of Saltaire around 1912. The faces of the Patterson children would come to personify the motto composed by the Fire Island Beach Development Company: "Saltaire, a Children's Paradise." (Courtesy Frank Mina Collection.)

ON THE COVER: Friends and loved ones are greeted at the Cherry Grove ferry dock in this c. 1953 photograph. In the background to the right is the Cherry Grove Community Theatre, established in 1948. To the left is Duffy's Hotel, which was known as Perkinson's Hotel until 1938. Duffy's would succumb to a fire in 1956. (Courtesy Cherry Grove Archives.)

IMAGES
of America

FIRE ISLAND
BEACH RESORT AND
NATIONAL SEASHORE

Shoshanna McCollum
Foreword by Gerard Stoddard

ARCADIA
PUBLISHING

Copyright © 2012 by Shoshanna McCollum
ISBN 978-0-7385-9133-9

Published by Arcadia Publishing
Charleston, South Carolina

Printed in the United States of America

Library of Congress Control Number: 2011938290

For all general information, please contact Arcadia Publishing:
Telephone 843-853-2070
Fax 843-853-0044
E-mail sales@arcadiapublishing.com
For customer service and orders:
Toll-Free 1-888-313-2665

Visit us on the Internet at www.arcadiapublishing.com

In loving memory of my mother, Brina Cohen;
she always knew how to tell a good story.

Contents

Foreword 6

Acknowledgments 7

Introduction 9

1. A Barrier Island 11

2. Lighthouses, Lifesavers, and Lodgings 15

3. Rise of the Resort Communities 33

4. Icons 47

5. Wrath of Storms 69

6. Fire Island National Seashore 83

7. Nature in the Balance 95

8. The Building Beach 105

9. A Beach Heritage 113

Bibliography 125

Index 126

About the Organization 127

FOREWORD

The author's introduction notes the role of Fire Island residents in making Fire Island a national seashore. To me, "residents" includes not only those lucky enough to spend the whole or part of each year on the island, but also the generations of families that cross the bay to enjoy the ocean beaches on so many fine summer days. Many who helped gain national seashore status for Fire Island remain active in its affairs today: Murray Barbash and Irving Like, both summer residents of Dunewood, and Bob Spencer of Davis Park come readily to mind. Not to be forgotten either are my predecessors: Arthur Silsdorf, later mayor of Ocean Beach; Charles Lowry of Point O'Woods; George Biderman and Norma Ervin, both of Saltaire; and John Stearns, also of Point O'Woods. Each applied unique talents to the task of presiding over meetings of the Fire Island Association (FIA) board, often at times of crisis.

When a Fire Island community names someone to head its property owner group, the chosen finds that one of his or her duties is to sit at monthly meetings of the FIA. If elected an officer, they, along with the mayors of Ocean Beach and Saltaire, make up the executive committee. At monthly board meetings, directors express community views on shore protection, zoning issues, deer herd management, police protection, and a variety of other issues. Community heads usually become FIA directors because they care and are articulate about keeping Fire Island much as it was. This is hard to do in the face of the unrelenting economic and social pressures that lead to change.

Mutual understanding is essential. Property owners must work cooperatively with the seashore to preserve and better the island. From year-round residents to summer people, service providers to those longing for fewer vehicles of all descriptions, and bar and restaurant owners to those who treasure quiet, these people are motivated—at least in part—by a desire to keep Fire Island as it was when they chose to become part of it. That shared vision, however disparate at times, is what Fire Island can be if we are determined to make it so.

—Gerard Stoddard
President Emeritus
The Fire Island Association

ACKNOWLEDGMENTS

Folks from every corner of Fire Island generously opened doors of their homes, offices and especially their photo collections in order to make this book happen. They include: Babylon Village Historical Society, Maurice Barbash, Douglas Brewster, Harold Seeley of Cherry Grove Archives, James Engle, Jan Felshin and Edrie Fedrun, Fire Island Association, Frank X. Fischer, the Free Union Church of Ocean Beach, Donald Hester, Luke Kaufman, Leonard Grosso, Warren James, Joseph Lachat, Lee and Warren Lem, Milton Lubich, Russell X. Mayer, Warren C. McDowell, Dorothy Miller, Mark Miller, Frank Mina, National Park Service (NPS) Fire Island National Seashore, Francis "Sid" Parker, Peconic Baykeeper, the Pemberton family, Wallace Pickard, Point O'Woods Archives, Archives at Queens Library, Leslie Schwan, Jayne Baron Sherman, Suffolk County Historical Society, Suffolk County Water Authority, Alain Thomas, Jane Van Cott, Jud Whitehorn, and Dale Wycoff.

Special thanks goes out to cartographer Paul Pugliese, former mayor of Ocean Beach, for his handsome map designed especially for this book; Diane Abell and MaryLaura Lamont of Fire Island National Seashore, who went above and beyond the call of duty; Anna LaViolette and David Griese, who took an interest; Warren Boyd Wexler, Betsy Peters, Jeanne Vogel, and Russ Mayer, who took the time to look at drafts with a fresh set of eyes; my husband, John, and uncle Henry Schwartz. And last but not least, Gerard Stoddard of the Fire Island Association for making this opportunity possible.

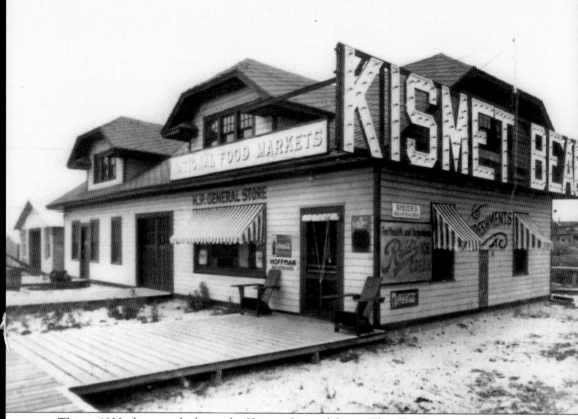

This c. 1930 photograph shows the Kismet General Store. The illuminated sign was a potent landmark that was visible from considerable distance upon arrival to the community from the Great South Bay. Sheide's carbonated beverages and Reid's Ice Cream, which were advertised on the side of the building, were popular favorites produced in Suffolk County during this era. The structure is now home to the Kismet Inn Restaurant. (Courtesy Russell X. Mayer Collection.)

INTRODUCTION

According to local legend, Jeremiah Smith holds the dubious honor of being the first resident of Fire Island. He was a "wrecker" or "land pirate," someone who survived by scavenging goods that washed up on the shoreline from the cargo of wrecked ships, possibly lighting false signal fires to lead the ships aground and having no compunction about doing away with any hapless survivors.

However, there are also accounts that Smith was responsible for bringing as many shipwreck victims safely ashore as those he allegedly murdered. If this were so, Jeremiah Smith was also the first lifesaver on Fire Island, preceding the US Lifesaving Service by several decades.

Smith was allegedly still active in the early 19th century, when the art of photography was just emerging. It is unlikely, however, that a man like Jeremiah Smith would ever agree to sit for a portrait, so we will never know what he looked like—that is, if he ever really existed at all.

Indeed, land piracy was hardly an activity limited to Fire Island. Appropriating goods that washed ashore was a time-honored tradition of many coastal communities en route to major shipping ports. Few of these places embrace their scrappy heritage with such relish, and this in itself is a very telling aspect of Fire Island.

While the signal fires from wreckers or whalers remain a persistent theory on how Fire Island got its name, this notion is far from conclusive. Were not similar fires ignited on barrier islands and peninsulas all along the East Coast? A more practical theory subscribes to the idea that the name is a product of some sort of language corruption, resulting from New York's transfer from Dutch to British control. The Dutch word for four is *vier*, which is a word that could have been misread as "fire" on maps of the age, since barrier islands constantly shifted as inlets opened and closed over time. Names of towns and enclaves of Dutch origin across New York are solid reminders of the state's early years when it was called New Amsterdam, Brooklyn being just one such example. Still yet another theory suggests that its name is credited to the intense color the sand dunes reflect during sunsets, and since there are limited points along the eastern coastline in America that allow such ocean side sunsets, there may be something to this.

Another once-common name for the island was simply the Great South Beach. As far as many surveys and navigational charts are concerned, this name is still technically correct. The Great South Beach is a name that is slowly fading from collective memory, if for no other reason than it is simply too generic, and a little boring. Fire Island may be many things, but it is never boring. The question about how Fire Island got its name will probably remain a matter of lightheartedly contentious debate for years to come. Perhaps all the theories are to some degree true, and fed one another to create Fire Island's name today.

This 32-mile-long shoestring-shaped strip of land, always less than a mile wide, is a dynamic geological formation that has allowed Greater Long Island to become a lush and gentle landscape by buffering the severity of the ocean's elements. The brackish body of water between Long Island and the barrier system, known as the Great South Bay, is a vital estuary that has been a source of nutritional and economic sustenance for generations. Tourism from Fire Island generates millions

of dollars worth of commerce and revenue for Suffolk County every year, and certainly the eastern Long Island municipality would be far less solvent without Fire Island's contribution.

Fire Island has autonomous residential communities within the boundaries of the Fire Island National Seashore (including West Fire Island), two of which are incorporated villages. There are also three town line borders within Suffolk County that cross over the island. Add the state agencies with vested concern, like New York Fish and Wildlife and the overall presence of the National Park Service itself, and Fire Island becomes a chowder of overlapping governing jurisdictions. Reaching consensus is often difficult.

In Fire Island's history, there have been some incredibly polarizing moments. In 1892, state militia units were dispatched in response to an angry mob comprised of baymen and respectable residents from the towns of Islip and Babylon. They had crossed the bay aboard three sloops to protest New York State's purchase of the once grand Surf Hotel in order to quarantine immigrants from Eastern Europe during a cholera scare. Whether or not the actions of the protesters were honorable is certainly a matter open for debate. Despite this, the incident signaled the kind of passion that could be generated for the welfare of Fire Island, and it foreshadowed events that would lie ahead in the next century.

Some 60 years later, the public was faced with what seemed to be the imminent prospect of a highway being built right down the middle of Fire Island. Residents of the various Fire Island communities, more often known for their disparate interests, found common ground and organized to petition congress for the establishment of the Fire Island National Seashore. Pres. Lyndon B. Johnson signed the enacting legislation into law on September 11, 1964. It was a hard-won battle that had been years in the making. This was a defining moment for Fire Island as well as a textbook example of American democracy in motion.

Nearly half a century later, these true events are almost a fable. Every summer, the story of how simple Fire Islanders joined forces to combat the ever-powerful Robert Moses to prevent him from building his road is proudly retold as if recalling a tie-breaking World Series game that happened decades ago. Those Fire Islanders were often more savvy than we are now led to believe, and when all is said and done, Robert Moses was just a mortal man.

When a dream becomes reality, it must be tended and managed into perpetuity. The Fire Island communities' relationship with the Fire Island National Seashore has not always been easy, yet it has endured.

In the 21st century, there are looming fears about global warming and rising sea levels. All it takes is a nameless nor'easter storm during the pull of a full moon to make abstract fears very real on Fire Island. The island could wash away one day and be no more. This ever-present possibility makes existence there feel that much more precious.

Sadly, what is discussed far less, but may well be a more immediate risk, is that Fire Island is loved just a little too much. The fragile island was never intended to hold over five million visitors a year. Inconsistencies between local and federal zoning standards have not controlled development of the communities within a national park as well as it should. Modest beach bungalows have, in many instances, been transformed into colossal edifices over the years and consume more energy resources to maintain them. The natural infrastructure of the island is strained almost to saturation levels. Is it possible to love an island to death?

Like the waters that surround the barrier island, Fire Island's history is a direct reflection of Long Island, New York City, and America itself. Residents are fortunate that such a wealth of visual documentation of Fire Island's history exists. Yet, there remains an elusive quality about Fire Island that is not so easily captured on film. Beautiful beaches can be found all over the world, but there is a certain tenacity of spirit that sets Fire Island apart from the rest. Its destiny has been shaped by the strong wills and personalities who have assumed roles of stewardship over many decades. This is a responsibility that should never be taken lightly.

One

A BARRIER ISLAND

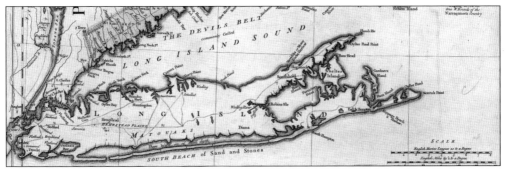

This detail of Thomas Jefferey's 1755 map calls Fire Island the "South Beach of Sand and Stones." It was not really an island at all, but a peninsula twice as long as it is today and connected near the Hamptons. Storms would continue to open and close inlets repeatedly over the next three centuries. The Moriches Inlet would break through in 1931, making Fire Island a true island once again. (Courtesy Geography and Map Division, Library of Congress.)

Fire Island is part of a barrier island system that runs parallel to Long Island's south shore. How barrier islands develop is not completely understood by scientists, but their origins are generally credited to glacial deposits that formed during the last ice age. Outwash sand was left behind from melting ice sheets and shaped into landmass from wind and tidal action. Sea levels rose, and then stabilized. (Courtesy NPS, Fire Island National Seashore.)

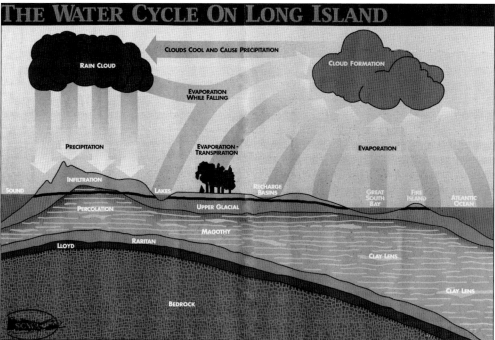

Fire Island has an abundant fresh water supply that is fed by Long Island's aquifer system. These ancient underground reservoirs bear names, much like any great body of water. The Upper Glacial Aquifer is the youngest, formed during the last ice age, and the Magothy is the largest, at over 1,000 feet deep. The Lloyd is the oldest at over 6,000 years and is 1,800 feet below the land surface. (Courtesy Suffolk County Water Authority.)

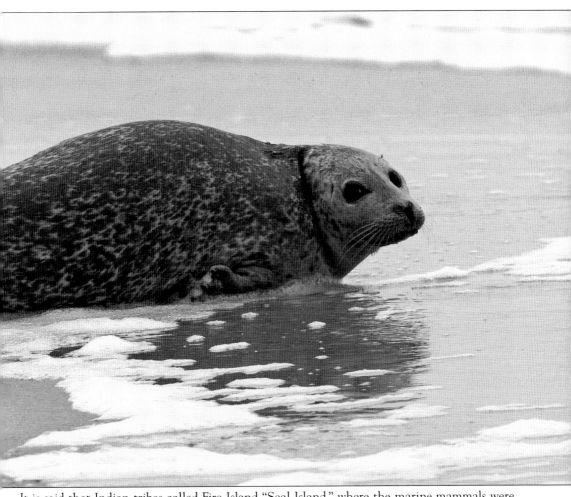

It is said that Indian tribes called Fire Island "Seal Island," where the marine mammals were plentiful. There were never Indian tribes exclusive to Fire Island, rather, Native American people of southern Long Island took advantage of the barrier islands for fishing, hunting, and the collection of wampum shells, which were vital to inter-tribal commerce throughout New England. By 1693, a large chunk of southern Long Island and the entirety of Fire Island were granted to Col. William "Tangier" Smith. Smith had been former mayor of British Colonial Tangier Morocco, Supreme Court chief justice, and once, briefly, acting governor of the Colony of New York. He established the Manor of St. George in present-day Mastic, New York, and deeded a small portion of his Greater Long Island lands to a sect of the Unkechaug Nation known as the Beach Indians, or the Poospatuck tribe. The Poospatuck Reservation is presently the smallest Indian reservation in New York and still exists on Mastic, Long Island. (Courtesy NPS, Fire Island National Seashore.)

After Tangier Smith's death in 1705, Fire Island's western half was transferred to his eldest son, Henry. Provisions in his father's will disallowed any subdivision of the land. Before moving on to Nova Scotia, Henry Tangier Smith's great-grandson sold the Fire Island property to 20 yeomen in 1789. Holding the Fire Island property in common, these yeomen used it to graze livestock. (Courtesy Fullerton Collection, Suffolk County Historical Society.)

In 1834, jurisdictional boundaries were drawn on Fire Island between Islip and Brookhaven. Descendants of William "Tangier" Smith still held on to some eastern portions of Fire Island, but land ownership disputes kept Fire Island relatively unsettled. This would all change in 1845, when a man named David Sammis started acquiring land parcels on Fire Island with visions of constructing a grand hotel. (Courtesy James Engle Collection.)

14

Two

Lighthouses, Lifesavers, and Lodgings

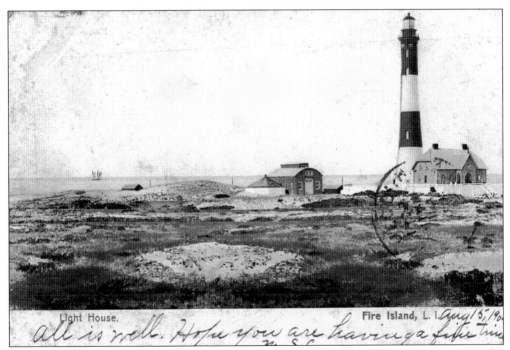

Light House. Fire Island, L. I. *Aug 15, 190*

all is well. Hope you are having a fine time

The Fire Island Lighthouse was the first landmark immigrants would see upon crossing the Atlantic and arriving at the United States. This beacon was essential for waterborne travel and commerce en route to New York Harbor and other local shores. Those were the days of great seafaring vessels, dramatic shipwrecks, and heroic acts of lifesavers. (Courtesy Babylon Village Historical Society.)

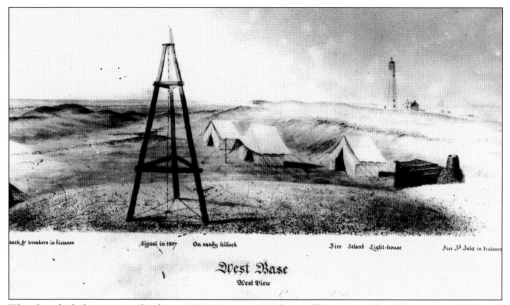

West Base
West View

The first lighthouse was built in 1826. It was a 74-foot-tall, cream-colored, octagonal-shaped structure built out of distinctive-looking Connecticut River blue split stone. This structure also represented the first federally acquired tract of land on Fire Island through a transfer of 31 acres from New York State to the United States Treasury Department. Most likely deemed inadequate due to its lack of height, the squat tower was replaced a mere 30 years later. No photograph of the old lighthouse is known to exist, but this 1837 ink sketch gives an honest idea of what it looked like (background, far right.) Today, a small ring of bricks still outlines its original footprint only a few hundred feet west of the present-day lighthouse. (Above, courtesy Russell X. Mayer; below, courtesy NPS, Fire Island National Seashore.)

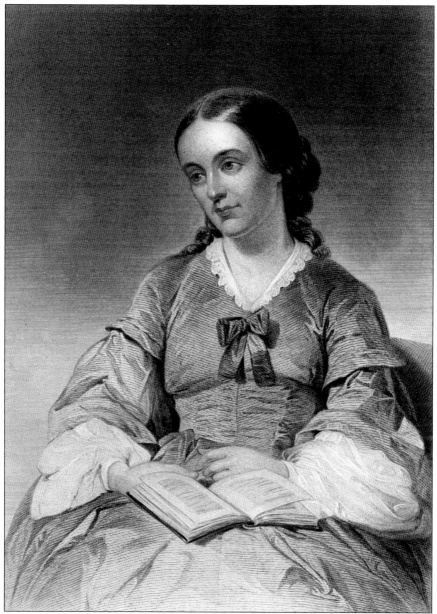

Under gale force winds on July 19, 1850, a ship named *Elizabeth* ran aground on a sandbar near Point O'Woods and broke up under a subsequent wave offshore of Fire Island. The shipwreck made headlines around the world because Margaret Fuller, a celebrated writer and feminist, was one of the passengers lost at sea. Her colleague Henry David Thoreau traveled to the scene days later in hopes of recovering her last manuscript, only to find people stripping the wreckage. Of this incident Thoreau wrote, "Once also it was my business to go in search of the relics of a human body . . . which had just been cast up, a week after a wreck, having got the direction from a lighthouse . . . the sandy beach, half a mile wide, and stretching farther than the eye could reach . . . When a cargo of rags is washed ashore, every old pocket and bag-like recess will be filled to bursting with sand . . . even after they had been ripped open by wreckers, deluded me into hope of identifying the contents." (Author's collection.)

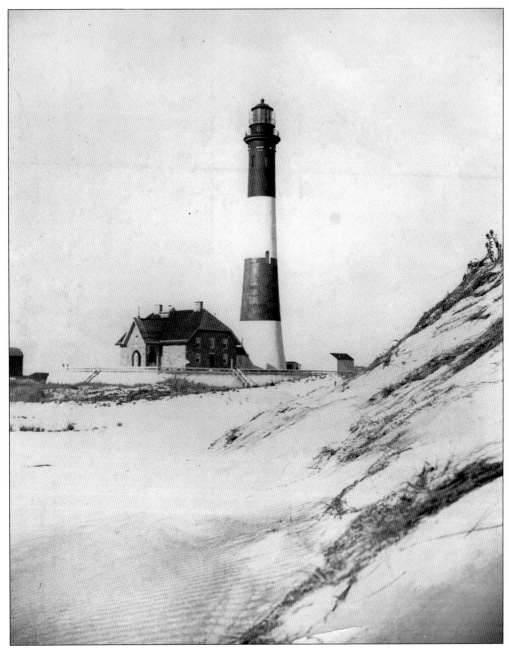

Public outcry from noteworthy shipwrecks like the *Elizabeth* was considerable and probably influenced the decision to upgrade the lighthouse. In 1858, the present Fire Island Lighthouse was erected. Standing a proud 168 feet tall, the distinguished tapered silhouette was at first a yellowish-cream color, much like its predecessor. The signature black and white bands seen today were adopted in 1891. The new keeper's quarters were built out of the Connecticut River blue split stones recovered from the original lighthouse. The US Lighthouse Board cited the Fire Island Lighthouse in their 1894 Annual Report as "the most important light for transatlantic steamers bound for New York. It is generally the first one they make and from which they lay their course." (Courtesy Babylon Village Historical Society.)

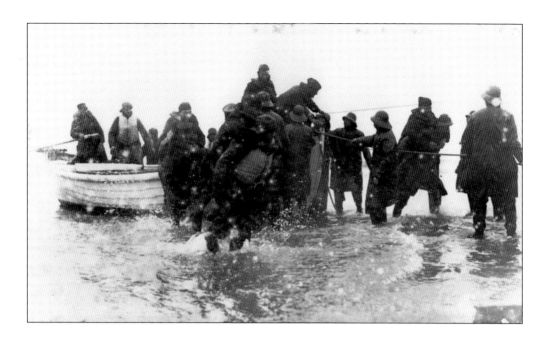

It took much more than lighthouses to save ships. Fire Island was known as being particularly treacherous for marine navigation due to the frequent presence of off-island sandbars and the challenges presented by the Fire Island Inlet. *Harper's Weekly* once wrote, "Every Captain of every kind of craft knows that Fire Island Inlet is one of the most difficult and dangerous on the Atlantic coast, and that it can only be navigated at high water, and with a pilot." The valiant feats of the US Lifesaving Service would be instrumental in saving lives on Fire Island. (Both, courtesy NPS, Fire Island National Seashore.)

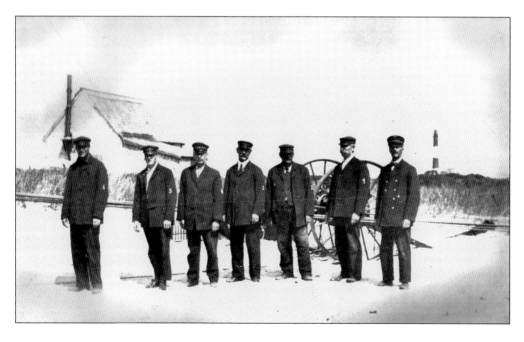

Maritime lifesaving on Fire Island began when a humanitarian group erected a few unmanned "huts of refuge" in 1805. By 1849, New York State sponsored the building of 15 such shacks along Long Island's coastline, all of them stocked with provisions. The problem was that supplies were regularly stolen. This hut had been converted into a small cottage when this early-1900s photograph was taken. (Courtesy NPS, Fire Island National Seashore.)

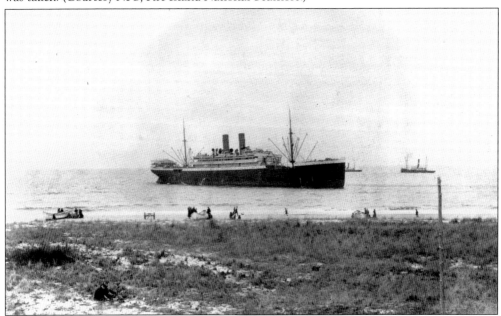

Before the existence of trucks or airplanes, in the 1800s shipwrecks did not just mean loss of life, but essential goods never reaching their destination. The US Lifesaving Service began as an offshoot of the Revenue Cutter Service, which was the customs enforcement branch of the federal government. By 1878, the USLSS had grown into a separate government agency. (Courtesy NPS, Fire Island National Seashore.)

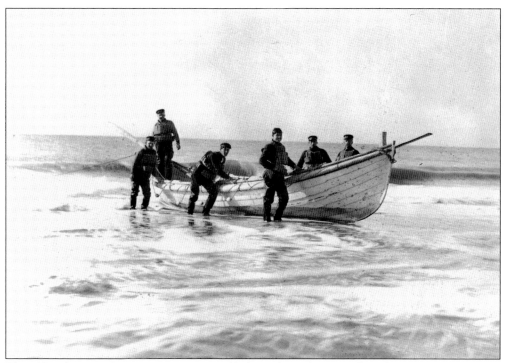

The US Lifesaving Service was a success all along the Atlantic seaboard but especially on the south shore of Long Island. Bay fishermen and farmers along the coast knew the unique hazards of their local waters like nobody else. The USLSS offered decent pay for these men to support their families along with top-notch training to improve their skills. Generations of such men on Long Island had risked their lives to help ocean-faring vessels in distress long before government agencies stepped in. Such volunteers were known as surfmen, and their unofficial motto was "You must go out, but you don't have to come back." (Above, courtesy Douglas Brewster; below, courtesy NPS, Fire Island National Seashore.)

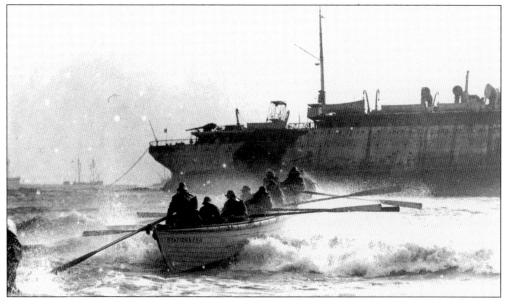

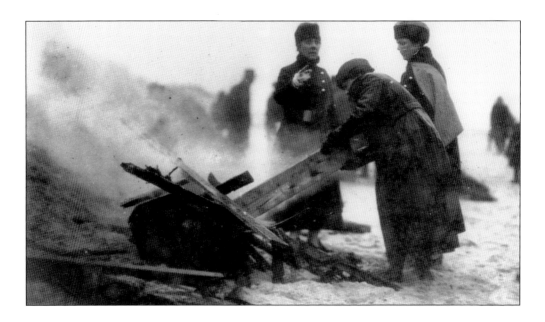

By 1880, volunteers from the Women's National Relief Association had also become a strong presence on Fire Island. They supported the US Lifesaving Service efforts by offering food, dry clothing, first aid, and the occasional cup of hot brandy to weary shipwreck victims. The annual report of the USLSS for the fiscal year ending June 30, 1903, cites their assistance on Fire Island in aiding seven individuals from a capsized catboat called the *Governor Hill* on August 7, 1902, and three men rescued from a sloop called the *C.W. Baker* on December 5, 1902. (Both, courtesy NPS, Fire Island National Seashore.)

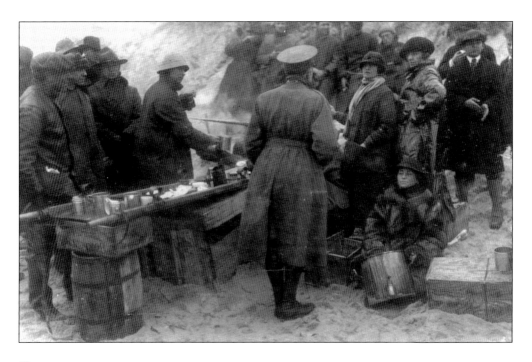

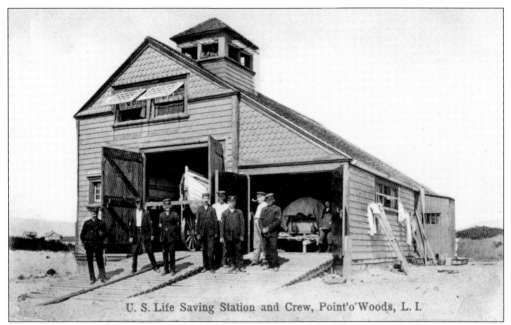

U. S. Life Saving Station and Crew, Point'o'Woods, L. I.

Like all USLSS stations along the East Coast, the Point O'Woods Lifesaving Station was a wood frame building with a large storage area to house rescue boats and equipment. It also had a lookout tower to patrol for distressed ships. Fire Island–based crews had to monitor both bay and oceanfront conditions for signs of trouble. (Courtesy Warren C. McDowell Collection.)

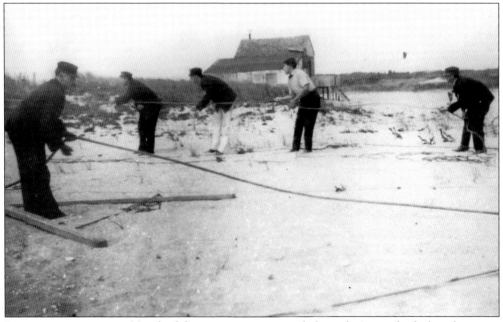

Rescue apparatuses used by the lifesavers may seem crude by today's standards, but they were effective nonetheless. Lines and pulleys used in conjunction with breeches buoys, weighted projectiles, and rescue boats comprised the basic tools of their trade. Regular practice drills kept their skills fine-tuned, exhibited by these men at the Point O'Woods Station in 1907. (Courtesy Frank Mina Collection.)

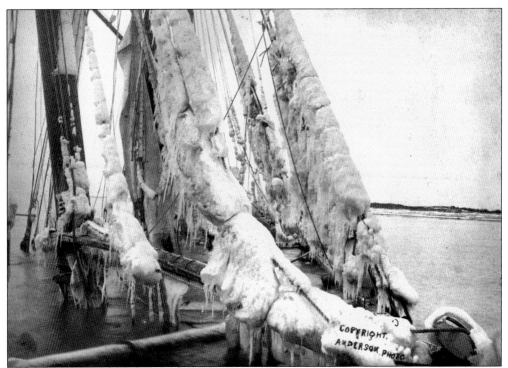

Not all Fire Island lifesaving ventures ended successfully. Among the more tragic is the *Louis V. Place*. She ran aground in 1895 near the Lone Hill Lifesaving Station during subzero temperatures. Mutual aid was enlisted from neighboring stations, but after 40 hours, only one man could be saved and eight frozen corpses were brought ashore. Seven of the men received proper burial at the Lakeview Cemetery in Patchogue, New York. In a sign of the ignorance of the era, the eighth sailor, a black man, was presumed to be a savage and buried in a nearby sand dune. When it was learned that this eighth sailor, named Sam, had been a devout Christian, attempts to recover his body were futile. Sightings of "Whistling Sam" continued into the 1950s, becoming one of the great Fire Island ghost stories. (Above, courtesy Warren C. McDowell Collection; below, courtesy Douglas Brewster Collection.)

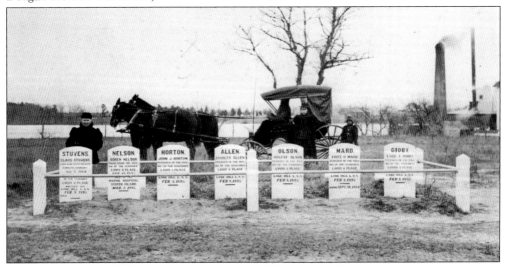

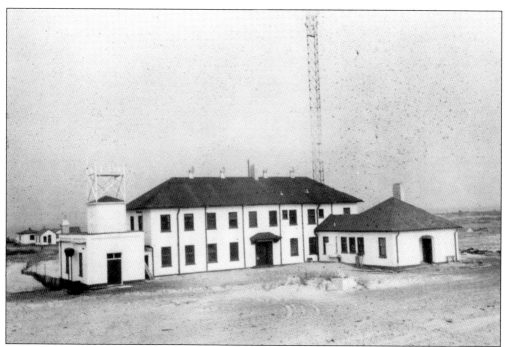

By 1915, the US Lifesaving Service again merged with the US Revenue Cutter Service, becoming what is now known as the US Coast Guard. Their legacy continues on Fire Island with a Coast Guard Station located on the island's western end. For over 37 years, the USLSS had aided 721 vessels and saved 7,086 lives, an impressive record indeed. (Courtesy NPS, Fire Island National Seashore.)

While the lifesavers were on patrol, the lighthouse keepers kept vigil. There is no question that this way of life was an isolated and lonely one for the keepers of the Fire Island Lighthouse and their respective families. These two unidentified children at play are leaning against the round base of the lighthouse. (Courtesy NPS, Fire Island National Seashore.)

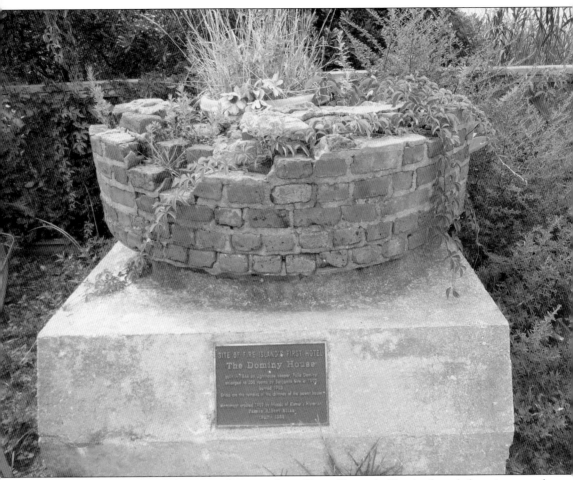

Felix Dominy was both keeper and gracious host. He and his wife, Phoebe, boarded tourists as early as the 1830s, and in 1843, lighthouse superintendent Edward Curtis wrote, "Dominy entertains boarders and company in his dwelling at the Island and devotes so much of his time and care to that, and other business personal to himself, that the public charge committed to him, is not faithfully exercised; his Light House [sic] duties are made subordinate objects of attention." Soon after that report was issued, he was relieved of his charge. He opened Dominy House the following year about a mile east, where the community of Kismet exists today. Considered the first hotel on Fire Island, it burned down amid shady circumstances in 1903. A small monument made of bricks from the original structure now sits in Kismet's public square. (Photograph by author.)

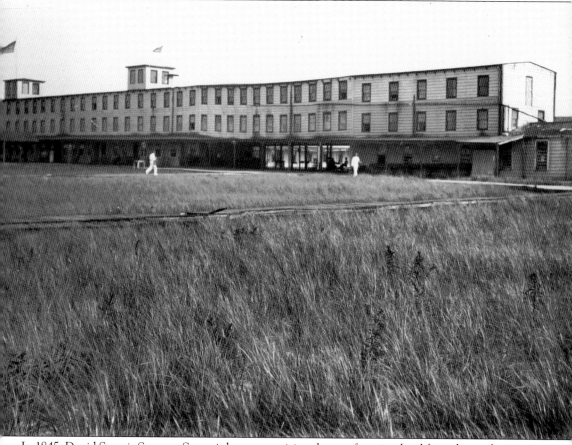

In 1845, David Sturgis Sprague Sammis began acquiring shares of grazing land from descendants of the 20 yeomen who Henry Tangier Smith had sold to in 1789. Within 10 years, he had gathered 120 acres and opened a simple chowder house that would expand into the Surf Hotel. The sprawling compound could accommodate over 500 guests, growing into "one of the largest sea-side establishments on the Atlantic coast," according to a *New York Times* article published in August 1880 and entitled, "Fire Island: A Cool Resort with a Hot Name—Beach Property on the South Shore—Long Island the Future Watering Place." The Surf Hotel, equipped with gaslights and recreational watercraft among other amenities, attracted elegant society and the political elite of its day, including John Jacob Astor III, Pres. Grover Cleveland, and Herman Melville, who completed his final novel, *Billy Budd*, while summering there. (Courtesy Suffolk County Historical Society, Fullerton Collection.)

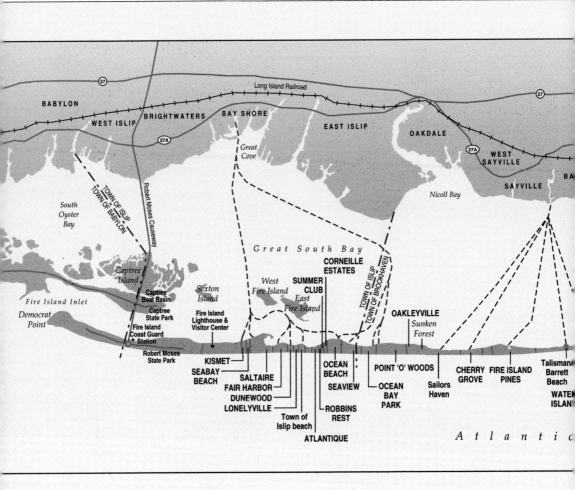

Claims by the heirs of the 20 yeomen, whom had been sold William "Tangier" Smith's great-grandson's Fire Island lands a century earlier, were questionable. Some suspected that individuals who deeded property to David Sammis had no legal right to do so. Claims were challenged in the court case *Green v. Sammis*. A seven-year title search ensued in which Sammis eventually prevailed. Perhaps more importantly, an 1878 survey entitled *Map of the Partition of the Great*

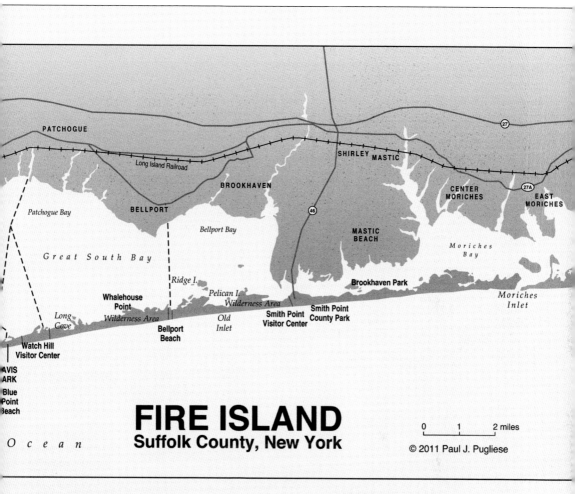

FIRE ISLAND
Suffolk County, New York

PATCHOGUE

Long Island Railroad

SHIRLEY MASTIC

BROOKHAVEN

BELLPORT

Patchogue Bay

Bellport Bay

CENTER
MORICHES

EAST
MORICHES

Great South Bay

MASTIC
BEACH

Moriches
Bay

Ridge I.

Pelican I.
Wilderness Area

Brookhaven Park

Moriches
Inlet

Whalehouse
Point
Wilderness Area

Long
Cove

Old
Inlet

Smith Point
Visitor Center

Smith Point
County Park

Bellport
Beach

Watch Hill
Visitor Center

AVIS
ARK

Blue
Point
Beach

O c e a n

27

46

27A

0 1 2 miles

© 2011 Paul J. Pugliese

South Beach in the Towns of Brookhaven and Islip was created. Legal disputes continued into the 1920s, but this document is the gateway to how Fire Island looks present-day. The subsequently developed highways, rail lines, and ferry routes would further supplement public access to Fire Island. (Courtesy Paul J. Pugliese.)

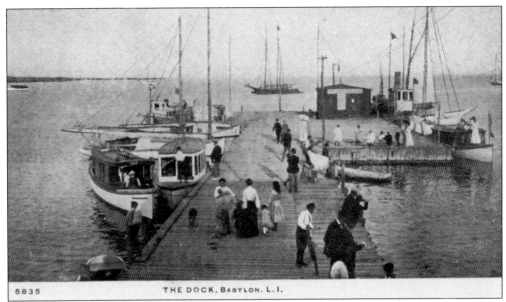

5835 THE DOCK, BABYLON. L. I.

Long Island's emerging railroads encouraged the success of the Surf Hotel. Travelers first came from a train station located in Deer Park. In 1867, the Babylon line was built, providing even closer access. David Sammis provided coaches and eventually a trolley to shuttle between the rail stations to where his boats were docked in Babylon—the first regular ferry service to Fire Island. (Courtesy Babylon Village Historical Society.)

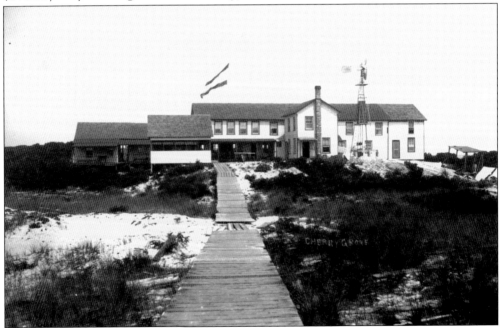

About seven miles east, Elizabeth and Archer Perkinson purchased land in 1868 where sour cherry trees grew in abundance. Local legend says that they had refurbished the structure originally inhabited by fabled wrecker Jeremiah Smith. Here, they opened a chowder house that would later be expanded into a hotel. In 1882, Oscar Wilde would stay at Perkinson's, where he would write of the island's beauty. (Courtesy Archives at Queens Library.)

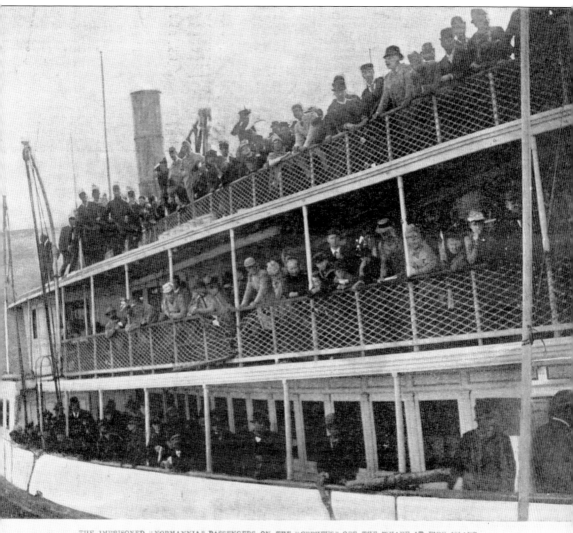

THE IMPRISONED "NORMANNIA" PASSENGERS ON THE "CEPHEUS" OFF THE WHARF AT FIRE ISLAND

By 1892, much of the glamour had faded from the aging Surf Hotel. Later that summer, several vessels crossing the Atlantic from Europe were determined to be carriers of cholera. Passengers deemed to be showing no signs of the disease—600 of them—were transferred to a day boat named the *Cepheus,* shown in the photograph above from the September 24, 1892, issue of *Harper's Weekly.* In a hasty transaction, New York State purchased the Surf Hotel for $210,000 in order to quarantine them. A September 11, 1892, headline from the *New York Times* reads, "KEEP OFF FIRE ISLAND! CITIZENS PREPARED TO DEFEND IT." An angry mob crossed the bay attempting to prevent the *Cepheus* from landing on Fire Island. Eventually, the passengers docked safely, thanks to an escort of military regiments dispatched by the governor. The cholera scare would soon pass, but bitterness from this event would linger for years. (Author's collection.)

David Sammis died less than three years after the cholera protest. New York State tried leasing the hotel, but this proved to be unprofitable. While some sources say the Surf Hotel was destroyed by fire (many hotels on Fire Island met such an end), others report of an ocean storm in 1907 that brought down some of the deteriorating buildings. Anything left was auctioned, torn down, or barged away. The following year, the New York State Legislature authorized the 120 acres originally acquired by David Sammis to become Long Island's first state park. Due to a phenomenon known as littoral drift, Fire Island had grown some five miles longer westward since the 1858 reconstruction of the Fire Island Lighthouse. In 1924, an up-and-coming young civil servant was appointed by the governor of New York to lead the Long Island State Parks Commission. The new commissioner made it his first order of business to annex much of this additional land to Fire Island State Park. The commissioner's name was Robert Moses. (Courtesy Russell X. Mayer Collection.)

Three

RISE OF THE RESORT COMMUNITIES

Fire Island awoke to the turning of the 20th century. Waterborne travel was still essential, but rail service and motorcars had much to do with making Fire Island more accessible. Every community evolved separately with its own story to tell. However, like the Dugan sisters of Saltaire, flocking to the beach and celebrating in the sun are one thing they all share. (Courtesy Frank Mina Collection.)

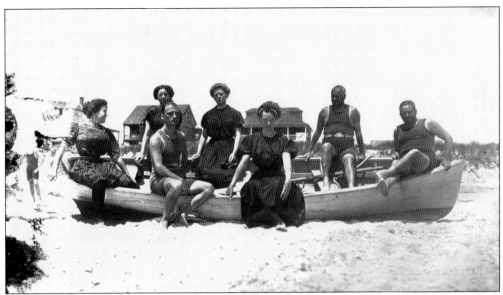

Theodore Roosevelt once called Chautauqua retreats "the most American thing in America." They may seem an obscure concept now, but in the late 19th century, these spiritual getaways of education, self-improvement, and enlightenment were all the rage. The desire to organize such an assembly in 1894 on Fire Island led to the settlement of Point O'Woods, the first residential community on Fire Island. This ambitious undertaking soon proved financially unsustainable and failed only four years later. While the Chautauqua was no more, the community of Point O'Woods continued to thrive. To this day, Point O'Woods property is held in common with 99-year leases while the houses are privately owned. Point O'Woods also launched the first public ferry service departing from Bay Shore instead of Babylon. (Both, courtesy the Archives at Queens Library.)

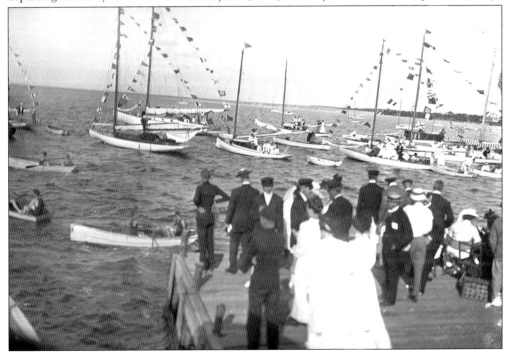

The Oakley family long had a presence on Fire Island, with members being employed as baymen, lifesavers, and fish factory workers. Offering their services to Point O'Woods as carpenters and domestic help, they soon established a modest hamlet due east, which took on the name of Oakleyville. Greta Garbo, John Lennon, and Robert Maplethorpe have been among its guests. This c. 1976 photograph shows Walter Oakley. (Photograph by Warren C. McDowell.)

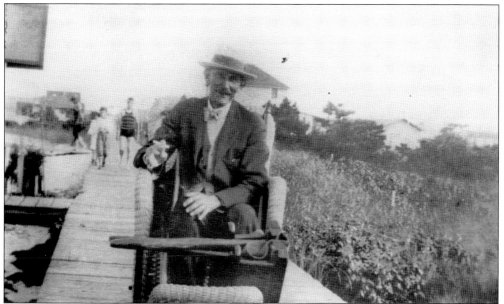

Lonleyville began as the Fire Island Fishing Company in the 1880s and was founded by Selah Clock, pictured above. He built a 400-foot oceanside pier so that fishing boats would not have to navigate Fire Island Inlet. A rail system took the fish across the island, where boats would transport it across the bay. By 1905, the business plan had changed into subdivision of the fishing company into residential lots. (Courtesy Frank Mina Collection.)

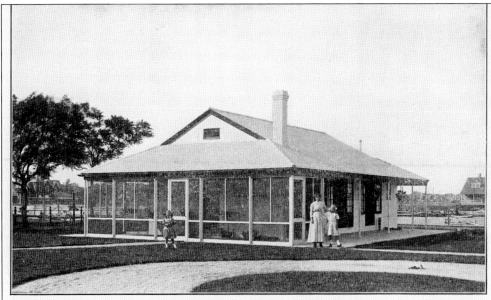

John A. Wilbur's Concrete Bungalow—Ocean Beach Impt. Co., Developers, Bay Shore, L. I.

"Ocean Beach is where health and happiness go hand in hand," claims the official motto of Ocean Beach. It began as two separate communities, Ocean Beach and Stay-A-While Estates. Businessman John A. Wilbur founded the Ocean Beach Development Company and began selling lots in 1908 with the vision of offering efficient beach bungalows attractive to a middle-class clientele. Wilbur built a grand place called the New Surf Hotel, an attempt to capitalize on the name of its predecessor, David Sammis's Surf Hotel. A fire destroyed the New Surf Hotel before 1920, and the two establishments are often confused to this day. Stay-A-While was founded by the heirs of New York Supreme Court justice Wilmot M. Smith in 1912. The sister hamlets merged to become the Incorporated Village of Ocean Beach in 1921. (Above, courtesy Frank Mina Collection; below, courtesy Warren C. McDowell Collection.)

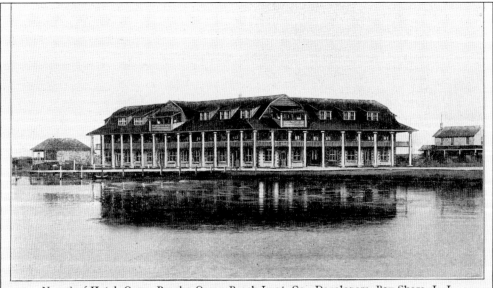

New Surf Hotel, Ocean Beach—Ocean Beach Impt. Co., Developers, Bay Shore, L. I.

Seaview began as a fish factory owned by Gilbert P. Smith. Unlike Selah Clock's company, which was intended to transport fish for food, processing plants like Smith's produced fertilizer and oil from menhaden fish. Such processing plants were popular industry on Long Island in the 19th century, but the stench was overpowering. Smith closed the factory and began selling lots from his land tract after 1907. (Courtesy Wallace Pickard Collection.)

Corneille Estates is often spoken of as a satellite community directly west of Ocean Beach. Indeed, its developer was briefly in partnership with Ocean Beach founder, John Wilbur. They maintained different business philosophies, however, and thus parted ways prior to 1912. The community developed independently in keeping with its own vision. This c. 1957 photograph shows a beach party hosted by Dana and Peggy Wallace. (Courtesy the Pemberton family.)

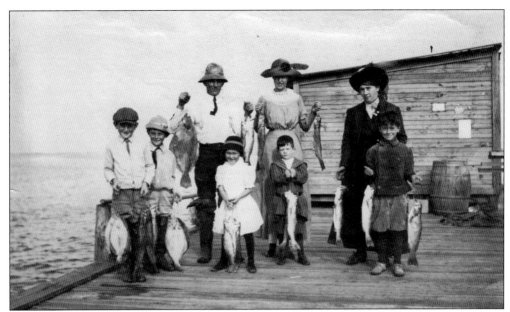

"Saltaire The Children's Paradise: The Last Word in Summer Bungalow Development," read one 1911 pamphlet circulated by the Fire Island Beach Development Company. It is commonly thought that the community is named for how it sounds phonetically: "salt air." Its true namesake is Saltaire, England, a village in West Yorkshire named after Sir Titus Salt that sits by the River Aire. By 1917, Saltaire became the first incorporated village on Fire Island. Capt. Herbert Patterson would often employ his children, Elmer, Amy, and Harold, and sometimes his wife, Elizabeth, in the Fire Island Beach Development Company's promotional material. This created an archetype idyllic image of what life on Fire Island promised to be. His marketing campaign proved very successful indeed. (Both, courtesy Frank Mina Collection.)

Carlton Brewster and Dr. George King founded the community of Atlantique in 1912. The neighboring western strip, originally known as Sea Fire Beach, was subsequently purchased by Islip for use as a town park and renamed Atlantique Beach. With a substantial public marina, Atlantique Beach offers recreational boating and bathing to the residents of Greater Long Island, while the community proper has remained distinct. (Courtesy Douglas Brewster Collection.)

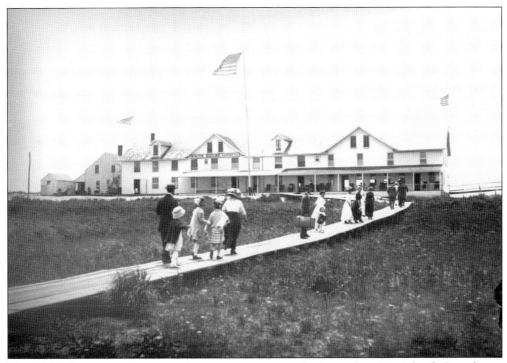

Water Island's name is deceptive, for it is not a separate landmass from Fire Island. Once home to the exclusive White House Hotel that was frequented by Theodore Roosevelt in the 1890s, Caldwell Realty Company began developing the area in 1912. Isolated from its respective eastern and western neighbors, Water Island became an ideal location for rumrunners during the Prohibition era. (Courtesy Archives at Queens Library.)

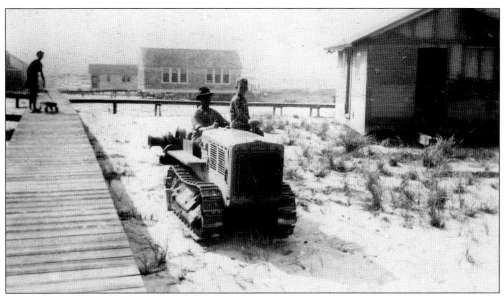

While some debate exists as to whether Point O'Woods or Cherry Grove was the first established settlement on Fire Island, it was not until 1921 when an actual community at the latter began to emerge. The Great Depression was followed by the hurricane of 1938, which hit Cherry Grove particularly hard. Homeowners, who relied on cottage rentals to make ends meet, were left with limited options. (Courtesy Donald Hester Collection.)

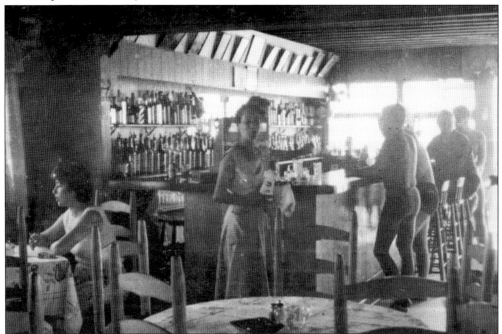

In a parallel development, homosexuals, who were often made to feel ostracized in other Fire Island communities, became drawn to Cherry Grove in the 1940s. With economic necessity came tolerance, and then even compassion. Patricia Stephani (standing center) of Pat's Ocean View Restaurant was one such proprietor who welcomed an eclectic clientele. After World War II, Cherry Grove came to be regarded as a world famous gay resort. (Courtesy Cherry Groves Archives.)

Fair Harbor was established in 1923 when Lonleyville founder, Selah Clock, partnered with George Weeks to develop the hamlet. Conceived as a blue-collar family resort, they went bankrupt during the Great Depression and after the hurricane of 1938, which devastated the community. Fair Harbor rebounded after World War II with a strong metropolitan presence. This unidentified little boy and his four-legged companion are pictured in 1935 on Holly Walk. (Courtesy Warren James Collection.)

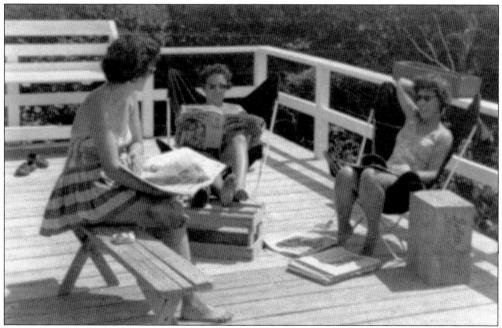

William Robbins founded Robbins Rest in 1925. He was a partner in the Bay Shore law firm Robbins, Wells, and Walser as well as namesake to the tiny community. Robbins Rest has always maintained a rustic, low-key charm. This c. 1955 photograph shows Nancy Pemberton (center) reading the Sunday paper with friends on her back deck. (Courtesy the Pemberton family.)

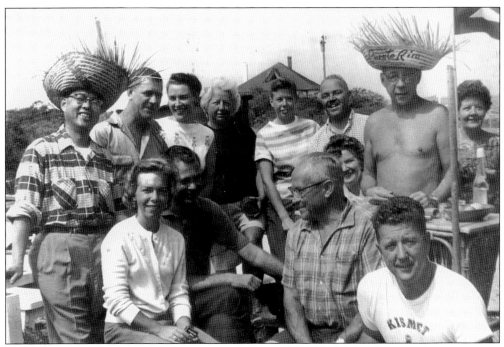

Where the Dominy House Hotel once stood, Kismet became the westernmost community on Fire Island in 1925. It subsequently merged with neighboring Lighthouse Shores and Seabay Beach. From left to right are (first row) Mary Began, Frank Began, Trudy and George Helm, and Richard Greenameyer; (second row) Arthur Lem, Bob and Edna Hodges, Jean Doherty, Shirley Greenameyer, John Doherty, and Alan and Evelyn Hathway. (Courtesy Lee and Warren Lem.)

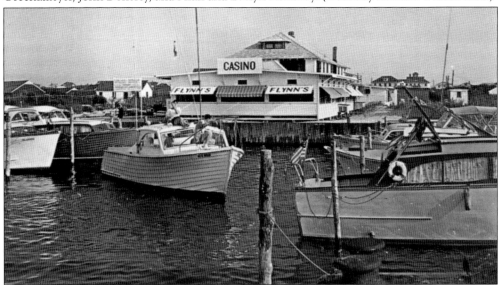

Ocean Bay Park was originally conceived as a retirement community for New York City police officers and firemen. By the late 1930s, such a prospect was a hard sell. In 1937, a man named John Flynn established a waterfront restaurant that in time would become the heart of the Ocean Bay Park community and synonymous with the casual Fire Island lifestyle. (Courtesy Warren C. McDowell Collection.)

Anne Whitehorn (left) is with two friends in Davis Park c. 1960s. The Davis family of Patchogue donated a tract of the island to the Town of Brookhaven in 1945. A public marina was built, and private community development followed. Davis Park is the easternmost community on Fire Island. Within it, one portion is known as Ocean Ridge. "Leja Beach" is also a long-standing alias for the community. (Courtesy Jud Whitehorn.)

Frederica "Toodles" Fischer-Grosso and her father, Andrew Grosso, sit in front of "The Pink" at the Fire Island Summer Club. Originally called Fire Island Beach Club, it was organized in 1946. Following the model set by Point O'Woods, land was held in common under 99-year lease terms, while the houses were privately owned. This practice eventually shifted to condominium governance, giving stakeholders the right of direct ownership. (Courtesy Leonard Grosso Collection.)

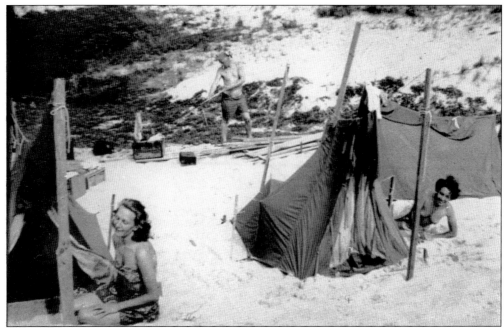

Fire Island Pines arose near the site of the Lone Hill Lifesaving Station between Cherry Grove and Water Island. The Home Guardian Company acquired the land tract in 1924, but development languished for decades, and a squatter nudist colony eventually took hold. In 1952, Home Guardian took new interest in the property. Arthur and Warren Smadbeck, who were in their day dubbed the "Henry Fords of Real Estate," subdivided the land and offered up 122 lots for sale. Along with its neighbor, Cherry Grove, Fire Island Pines rose to become a part of Fire Island's famous gay resort. The community is a strong mix of all lifestyles, including some of the artistic elite. Pictured below in 1967 is the Fire Island Pines Dog Show in front of the Sandpiper. (Above, courtesy Warren C. McDowell Collection; below, courtesy Milton Lubich.)

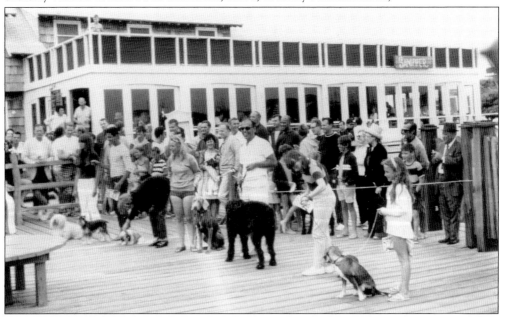

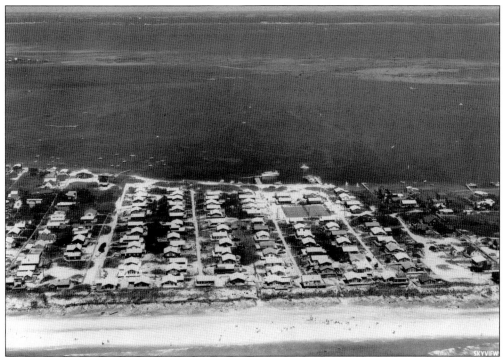

During a time when planned suburban developments were a dominant trend across the country, Dunewood was founded in 1958 and is the most recently established Fire Island community. All 100 houses offered on the market had an identical floor plan, thus were nicknamed "Levittown on the Bay." By sequentially rotating the floor plan, Dunewood's developer, Maurice Barbash, softened the cookie-cutter appearance that planned developments can have. (Courtesy Maurice Barbash Collection.)

West Fire Island is a separate landmass but was annexed into Fire Island National Seashore's jurisdiction with the enacting legislation in 1964. In its heyday, West Island boasted some 50 cottages, a ferry service, and a casino club during the 1920s. Much was taken by fire, storms, or demolition and never rebuilt again. It remains as the only populated satellite island under FINS auspices. (Courtesy Leslie Schwan Collection.)

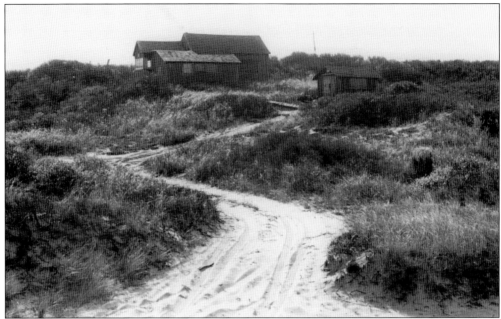

An overview of Fire Island communities cannot be considered complete without paying note to the eastern enclaves that once included Bayberry Dunes, Long Cove, Skunk Hollow, and Whalehouse Point, among others. Unlike their western counterparts, these houses ranged from tiny makeshift shacks to substantial dwellings but were not protected against condemnation in Fire Island National Seashore's enacting legislation. Ultimately, they were absorbed by what would become the Otis Pike High Dune Wilderness Area. Owners of these properties were given options, but not all were willing to leave quietly. Pictured above is the Bishop cottage east of Watch Hill, and below is the beach house of Edward Rant of Skunk Hollow around 1983. (Both, courtesy NPS, Fire Island National Seashore.)

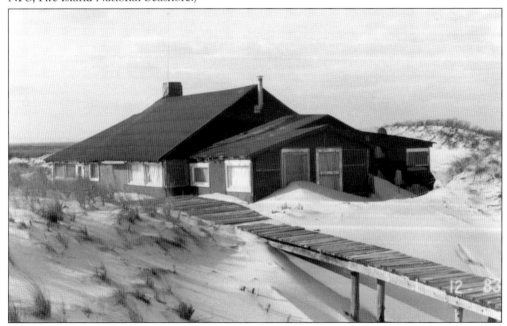

Four

ICONS

Some of Long Island's beach resorts attract the elite desperate to be seen. In contrast, Fire Island draws legends looking to get away from it all. Bob Dylan jammed in Skunk Hollow, and Marilyn Monroe sunned in Seaview like an ordinary girl. Stars like Fanny Brice and writers, such as Truman Capote, also passed through or even stayed a while longer. Fire Island's true icons, however, may not necessarily be celebrities. (Photograph by Milton Lubich.)

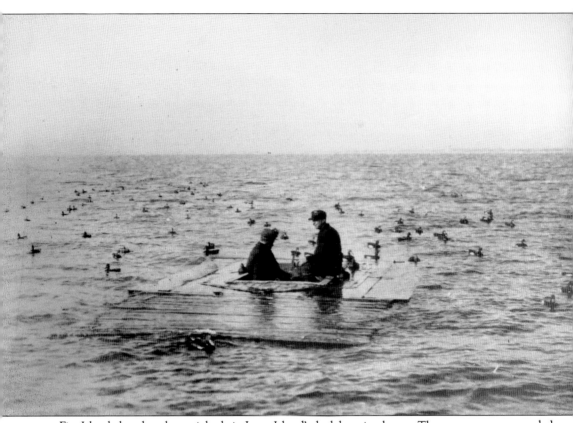

Fire Island played a substantial role in Long Island's duck hunting legacy. These two men surrounded by decoys are in a vessel called the South Bay Duck Boat, also known as a South Bay Scooter or South Bay Gunning Boat. Their signature square cockpits allow them to float semi-submerged so that they may be covered in seaweed and blend in with their surroundings. Aggressive harvesting by "market gunners" in the late 19th century supplied the finest New York City restaurants with game fowl, while often cruel hunting methods employed by so-called sportsmen began to threaten duck populations, as both a species and future food source. Federal protections like the Shea White Plumage Act of 1910 and the outlawing of market gunning in 1918 regulated practices. South Bay Duck Boats, now made of fiberglass instead of wood, are still used by duck hunters as well as wildlife photographers. Many of the public parks in Suffolk County directly resulted from acquisition of private hunting clubs that once dotted shoreline and wetlands. (Courtesy Luke Kaufman Collection.)

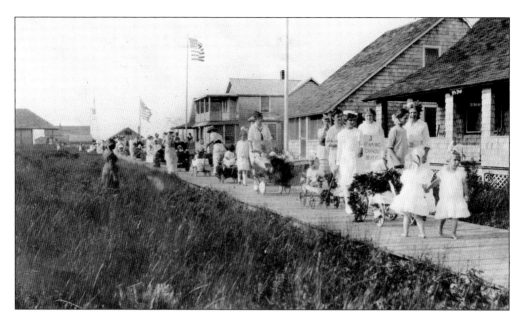

"Baby Parades," an Independence Day tradition, go back to the earliest years of Ocean Beach history. Children wear festive costumes as baby carriages and wagons are transformed into ornate floats. The parades were suspended during World War II but were revived upon the nation's bicentennial in 1976 and have continued since without interruption. The parade always manages to document important events of their day with candor. These shots were taken in 1914, and the "first aid unit" as seen below won first prize for creativity as World War I was just starting up in Europe. (Both, courtesy Free Union Church.)

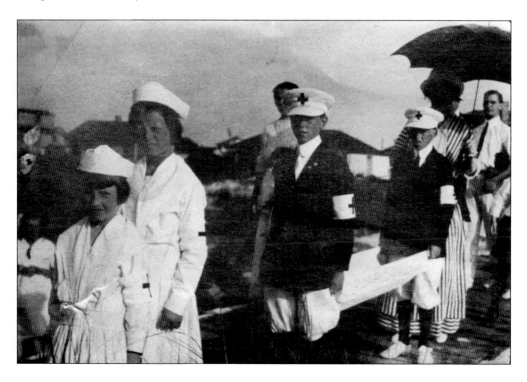

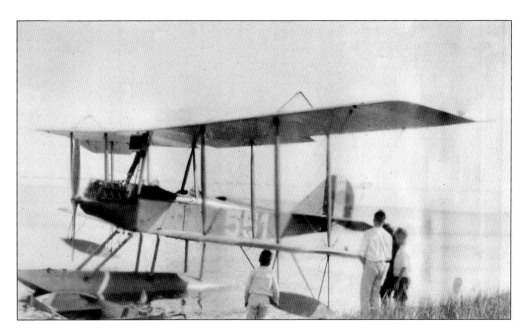

Naval Reserve Aero Stations located in the Bay Shore and Mastic hamlets on Long Island made seaplane sightings on Fire Island commonplace during World War I and were named the Aerial Coast Patrol Stations No. 2 and No. 3, respectively. The Mastic Station was also known as Knapp Seaplane Base due to its close proximity to the Knapp Estate, while the Bay Shore Station was called Gardiner Base because of its location on Gardiner Lane. The stations served as training centers from 1916 to 1919 and patrolled the Long Island shoreline against the threat of German U-boats. The freshman aircraft pilots frequently made emergency landings in the shallow bay, thus many photographs that found their way into family collections are of disabled planes. (Above, courtesy Frank Mina Collection; below, courtesy NPS, Fire Island National Seashore.)

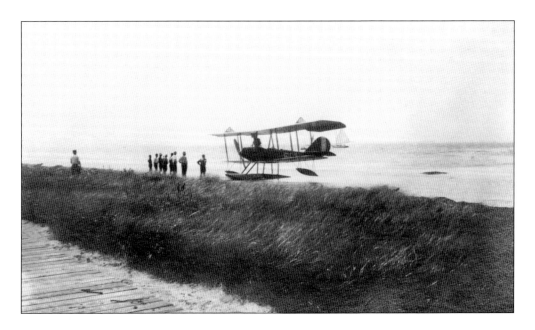

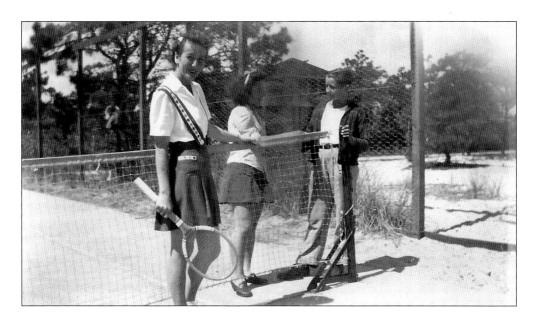

World War II left its imprint on Fire Island much like it did the rest of the nation. "There were no men on the beach except for old men, young boys, and a few French refugees," recalls Dorothy Miller. In August 1944, she and some girlfriends took a vacation from their wartime factory jobs on Long Island, and their brief respite on Fire Island created memories that would last a lifetime. Fire Island was not entirely without prime-aged men during the war, since Army soldiers had been stationed at Point O'Woods working in conjunction with the Coast Guard to patrol the barrier beach, as Fire Island is part of the US border. (Above, courtesy Dorothy Miller Collection; below, courtesy Point O'Woods Archives.)

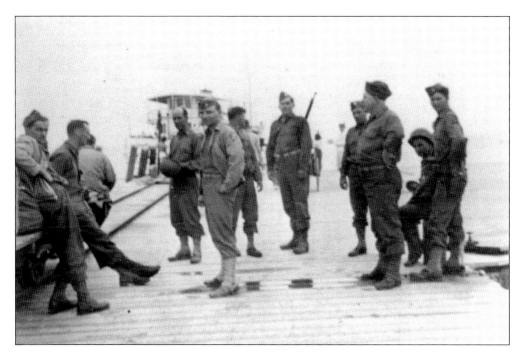

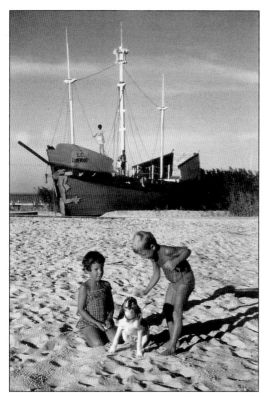

During the early decades of the 20th century, finding respite from polio outbreaks triggered over the summer months in urban areas was one factor that made the Fire Island communities attractive to families. Even after the vaccine had been discovered, the absence of automobile traffic and pollution made it possible for children to play in relatively safe and clean conditions. The independence children can enjoy on Fire Island still remains appealing to families. Many who grew up on Fire Island stayed on as adults to raise their own families, creating a strong multigenerational tradition. Pictured in 1959 at left are Susan Barbash and Steve Robinson with his dog Sneakers. Note that the SS *Dunewood* in the background was never a seaworthy ship. Pictured below in 1968 are Adam Siegler (left) and Jud Whitehorn (right) in Davis Park. (Left, courtesy Maurice Barbash; below, courtesy Jud Whitehorn Collection.)

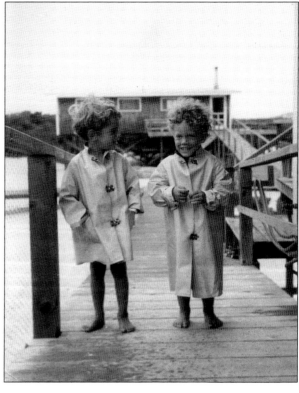

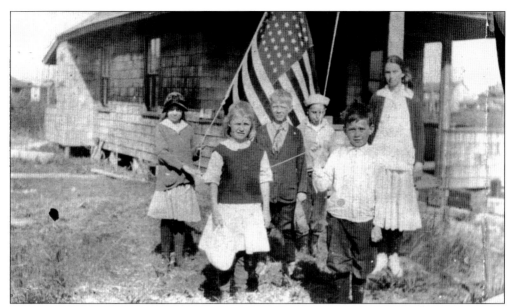

There have been schools on Fire Island since 1918. In 1924, a one-room schoolhouse in Ocean Beach opened with Florence M. Lee as its first schoolteacher. The boy in the foreground of the above photograph is young Richard Woodhull. He grew up to become school principal and eventually the namesake of the elementary school built in 1954 at Corneille Estates. Prior to the construction of the Robert Moses Bridge, high school students boarded with mainland families in Bay Shore during the winter months. They were later bussed to Bay Shore secondary schools in Jeeps after the bridge was built, and it was often a rough ride. Woodhull Elementary School serves the Fire Island communities as well as the families living at the US Coast Guard Station to this day. (Above, courtesy Luke Kaufman Collection; below, courtesy Warren C. McDowell Collection.)

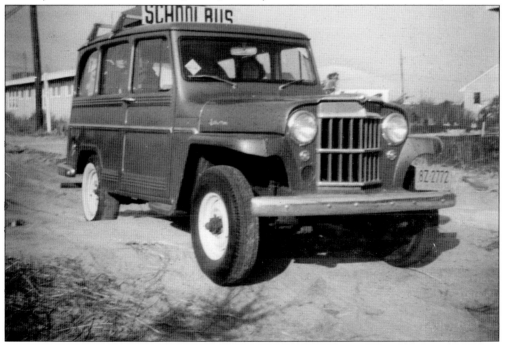

Enticed by opportunity, builders came to the beach with their families in the early 1900s to realize a prospector's vision of what the Fire Island communities should look like. Some became established home and business owners in their own right and stayed on for multiple generations, the Stretch family of Ocean Beach being a prominent example. (Courtesy Dale Wycoff collection.)

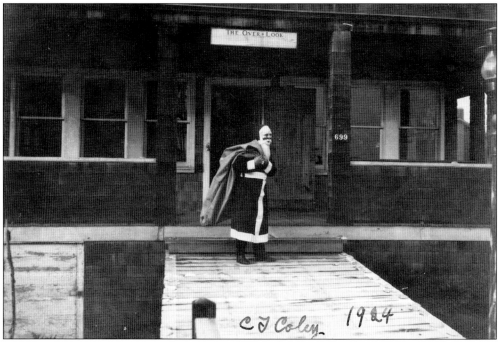

Even Santa could become lonely on Fire Island during the off-season, when the population dwindles and summer homes sit empty. This was just as true in the year 1924 as it is today, with only about 500 residents remaining on the island even in the 21st century. Still, as desolate as Fire Island can be this time of year, it maintains a stark beauty. (Courtesy Dale Wycoff Collection.)

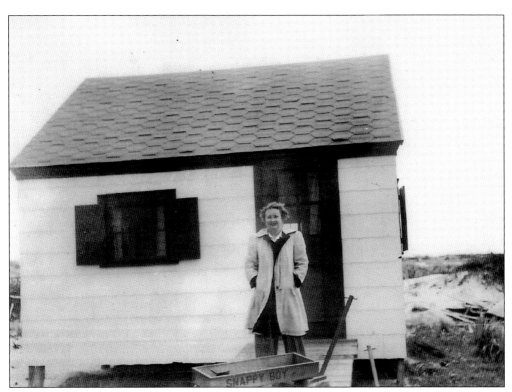

Catherine Hoag is pictured around 1945 in front of "Snappy Boy," her Cherry Grove cottage. The decision to name cottages akin to boats is a more curious tradition, and the wagon is an absolute necessity on Fire Island. Both remain constants associated with the Fire Island lifestyle, regardless of community. (Courtesy Donald Hester Collection.)

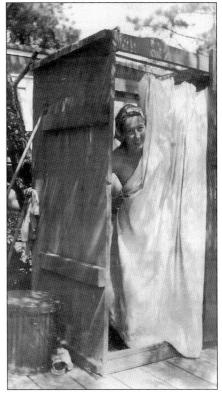

Outdoor showers have a rustic charm, but they remain a fixture on Fire Island because they are an efficient way to wash off the sand after a day at the beach while still keeping the cottage clean. Also, nothing is quite so refreshing, as Shirley Domaglia may have attested when this snapshot surprised her during a stay in the 1940s. (Courtesy Dorothy Miller Collection.)

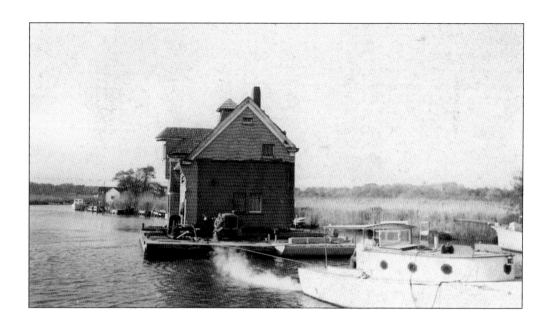

Floating fully constructed buildings across the Great South Bay was a common practice in the first half of the 20th century. The relatively flat, unobstructed terrain made this process nearly ideal on Fire Island when the development of communities was still in its infancy. It also made sense economically, since barging raw materials could be more costly with hardware, such as nails, being strictly rationed during World War II. In the photograph above, this late-19th-century structure was to be reborn as the Cherry Grove Community Arts Center, which has held countless stage productions in the decades that followed. Sometimes livestock came along for the ride. (Above, courtesy Donald Hester Collection; below, courtesy Wallace Pickard Collection.)

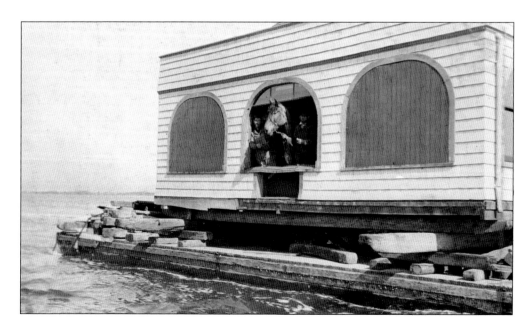

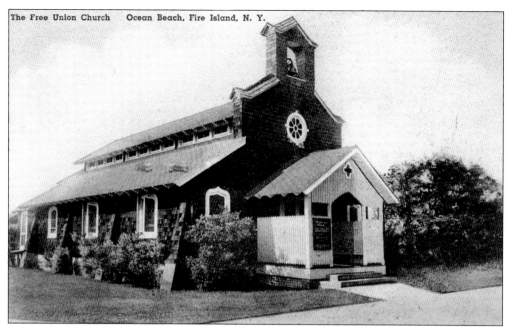

The Free Union Church Ocean Beach, Fire Island, N. Y.

As people built cottages on Fire Island, they also assembled houses of worship. Pictured are the Free Union Church in Ocean Beach and the Church of Point O'Woods, both of them nondenominational. Catholic churches include Church of the Most Precious Blood in Davis Park, Our Lady of the Magnificat (also in Ocean Beach), and Our Lady Star of the Sea in Saltaire. Also located in Saltaire is the Episcopalian church, St. Andrew's by the Sea. The two synagogues on the island are both in Seaview. Fire Island Synagogue was founded in the 1950s by renowned author Herman Wouk. The Fire Island Minyan is the most recently established religious institution on Fire Island, organized after the year 2000. (Above, courtesy the Union Free Church; below, courtesy James Engle Collection.)

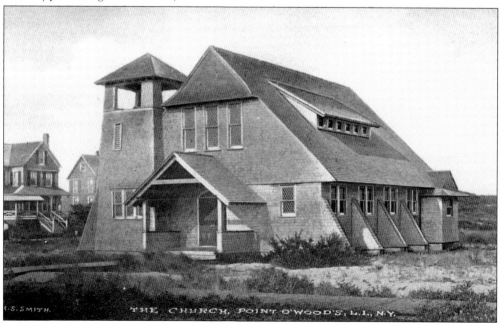

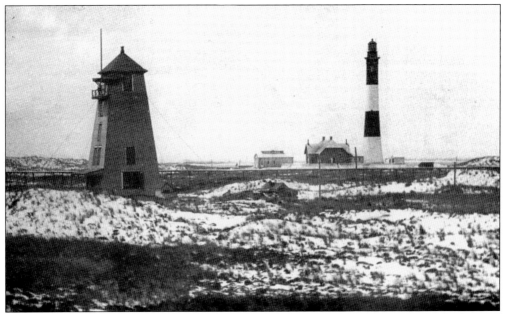

The Western Union Telegraph Company's original headquarters was a cupola inside the Surf Hotel, where marine service operators would report the impending arrival of approaching ships to New York City ports. By 1885, David Sammis leased Western Union a small lot of property to build the signal tower. The station was decommissioned in 1920 and ultimately washed out to sea in 1931. (Courtesy James Engle Collection.)

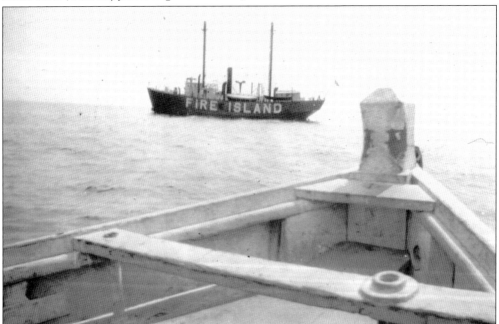

The Fire Island Lightship Station was intended to serve as a supplement to the lighthouse. Positioned by the US Coast Guard about nine miles off the coastline, three different ships served in this capacity over the 46 years it was in commission, from 1896 to 1942. (Courtesy Dale Wycoff Collection.)

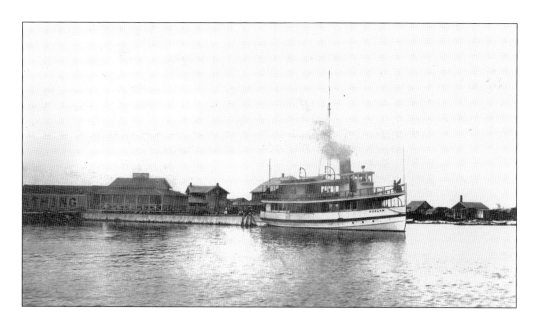

Ferry travel has long been a way of life on Fire Island. Mainland terminals in Bay Shore, Sayville, and Patchogue service the western, central, and eastern communities, respectively. These grand vessels have been a fixture in the Great South Bay for over a century, providing essential transportation as well as employment for generations of Long Islanders. In the c. 1915 photograph above, the *Evelyn* departs from the Ocean Beach ferry basin. In a strange twist of events, boats that once sped across the Great South Bay as rumrunners during Prohibition, such as the *Artemis*, were later converted to ferries in part due to their fine craftsmanship and technical innovation. (Both, courtesy Frank Mina Collection.)

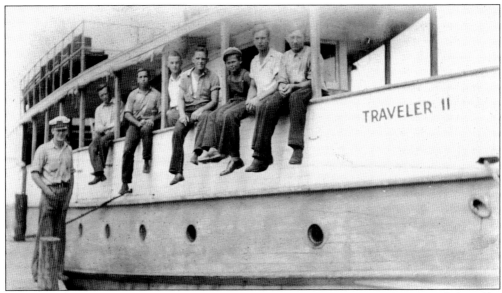

A ship is only as good as her crew. Ferryboat captains and their crews have long been beloved by their ridership for their skill, bravery, and unwavering steady hand displayed as they navigated the Great South Bay waters in fair or foul weather. The strapping young fellows who ran the *Traveler II*, pictured around 1930, are one such example. (Courtesy Frank Mina Collection.)

Ferries carry people, but freight boats bring the cargo. They are the lifelines for Fire Island as they deliver mail, building material for construction projects, and food supplies to the markets and restaurants. Freight houses are only open a few hours a day but are major hubs of activity during that time. (Courtesy Frank Mina Collection.)

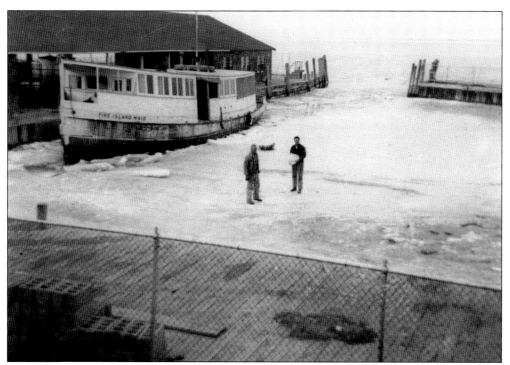

In the mid-1950s, John VanBree and his friend knew that a frozen bay brings waterborne travel on Fire Island to a grinding halt in the winter months, however, necessity brought innovation. Geraldine, Anna, Bob, and George Stretch made good use of their iceboat. Sometimes called ice scooters or pumpkin seeds, these vessels on skis could glide across the frozen Great South Bay by either sail or motor. Construction of the bridges in the later half of the 20th century eliminated the need for such ventures. In addition, due to statistically shorter and warmer winters, the ice is rarely solid enough to cross the frozen bay safely in this fashion anymore. (Above, courtesy Frank Mina Collection; below, courtesy Dale Wycoff Collection.)

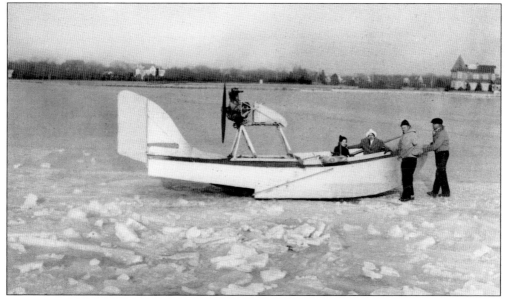

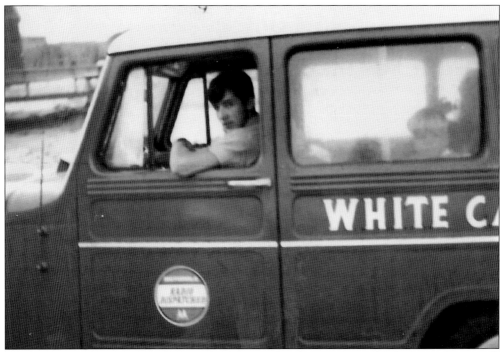

White Cap beach taxi was once the standard for traveling between Fire Island communities. With the regulations imposed by the Fire Island National Seashore, the beach taxi practice was soon prohibited, and companies like White Cap dissolved in the late 1960s. With their demise, the water taxi industry emerged, filling the need for lateral transportation on Fire Island. Baymen had been willing to take parties to Fire Island for hire since the days of the Surf Hotel. The first commercial water taxis became present in the late 1940s. Like *Socks*, they were Chris Craft vessels adapted for commuting purposes, but such businesses for the most part remained one man with a boat. By the 1970s, water taxi companies had evolved into organized fleets that kept in contact via radio dispatch. (Above, courtesy Jud Whitehorn Collection; below, courtesy Luke Kaufman Collection.)

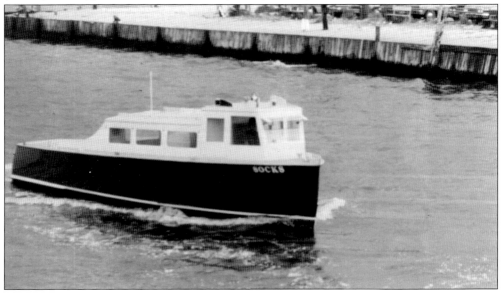

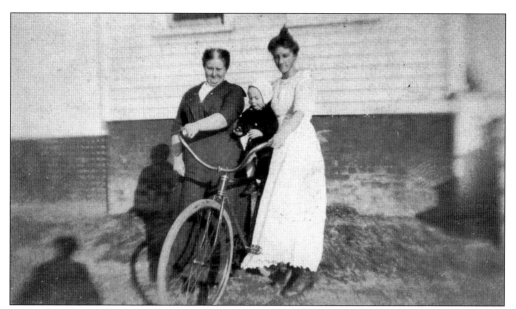

Lack of traditional roadways and regulation of truck and automobile driving has encouraged the use of bicycles and golf carts, which thrive in Fire Island culture. Bicycles are not just for recreation or exercise. Golf carts serve in many functions that have nothing at all to do with the game of golf. Indeed, motorized mules, utility carts, and other all-terrain vehicles are essential to move freight and even save lives when adapted for use by police, firefighting, and EMS crews, as illustrated below by the Fair Harbor Fire Department. Where use of traditional automobiles just does not make sense, these alternatives have become a staple to the Fire Island way of life. (Above, courtesy Dale Wycoff Collection; below, photograph by Warren C. McDowell.)

Is it really so ironic that fire should be such a serious concern on a place named Fire Island? Dry sea brush combined with ocean wind carries the potential of catastrophic consequences if the situation is not contained quickly. As a result of these conditions, the volunteer fire departments on Fire Island are among the finest on Long Island. Davis Park, Fire Island Pines, Cherry Grove, Point O'Woods, Ocean Bay Park, Ocean Beach, Fair Harbor, Saltaire, and Kismet make up the fire departments that run east to west along Fire Island. Equipment is often adapted to accommodate narrow boardwalks and other unique conditions. Pictured at left around 1950 are, from left to right, June, Frank, Sheila, and Nat of Cherry Grove. Below, c. 1975, are Frank Fischer and Chief Tom Koller of Ocean Beach Fire Department. (Left, courtesy Cherry Grove Archives; below, courtesy Francis "Sid" Parkan and Frank X. Fischer Collection.)

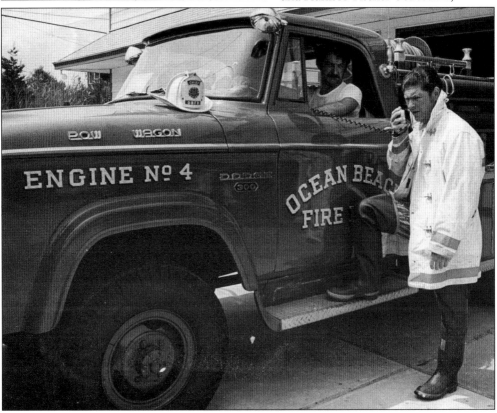

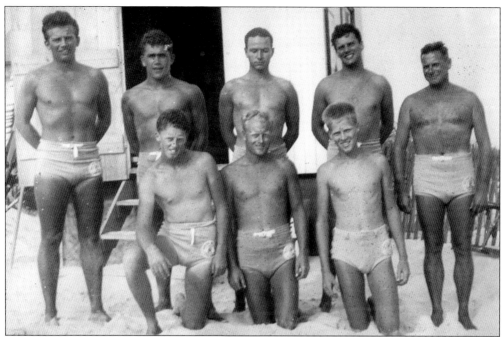

The US Lifesaving Service may have ceased to be in 1915, but lifesaving endured on Fire Island. Lifeguards have saved countless lives over the decades, as the riptides and undertow can be especially treacherous along the island's shores. What these two photographs have in common is the presence of "Buck" Wright, who was head lifeguard in Ocean Beach for over three decades. In the above c. 1930 photograph are, from left to right, (kneeling) Chet "Reds" Colley, Bob Stretch, and Jackie O'Connor; (standing) Chuck "Chubb" Edward, Don Andrus, Joseph "Chi" Kelly, "Peb" Edwards, and Buck Wright. Pictured below in 1956 are, from left to right, (kneeling) Ocean Beach Lifeguards Pat Gillespie, Phil Rumpelt, Tom Unkenholtz, head lifeguard "Buck" Wright, Joe Puleo, and Dave Richardson; (standing) Walter Strobach, Tim Dunn, Frank Ferren, Ken Ederle, Phil Limpert, Pete Israelson, and Mike Minsky. (Above, courtesy Dale Wycoff Collection; below, author's collection.)

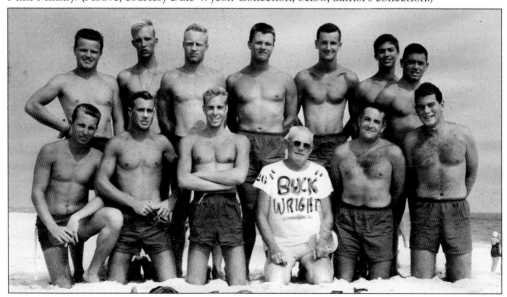

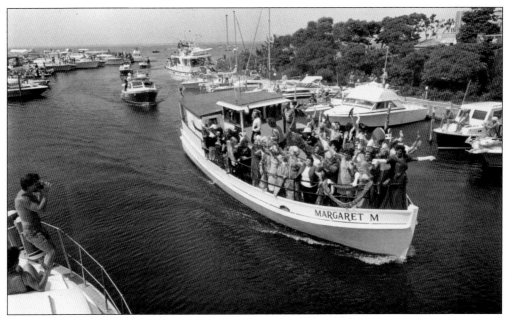

The Invasion is now a Fourth of July tradition on Fire Island, but it began as a spontaneous protest in 1976 when a Fire Island Pines restaurant proprietor, John Whyte, refused to serve a cross-dresser. In response, a dozen or so men and women from Cherry Grove boarded a water taxi wearing the most outrageous outfits they could devise. When they landed in the Pines, they were an instant hit. By the year 2000, the Invasion had become an annual multimillion-dollar-generating event that today attracts thousands. A double-decker ferry must be chartered, and it remains a festivity that has no equal. (Above, photograph by Warren C. McDowell; below, courtesy Cherry Grove Archives.)

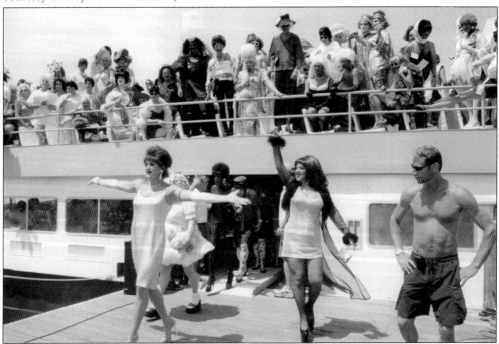

Nightlife on Fire Island is every bit as famous as the beaches. Restaurants double as nightclubs, discotheques, and neighborhood watering holes, and parties hosted at private residences remain a constant. There is always potential for romance and good times. Waiting tables on Fire Island has also been an important resource for young people putting themselves through college. Every community has its own unique spin—Fire Island Pines is known for "tea dances," and the "sixish" bay-side cocktail party has been a favorite at Davis Park. All are fixtures in the communities they serve for residents and tourists alike. Pictured at right around 1949 are John and Joan Maguire with Dana Wallace Jr. at Sis Norris's. Pictured below in 1974 is the "first clean up" at the Kismet Out. (Right, courtesy the Pemberton family; below, courtesy Lee and Warren Lem collection.)

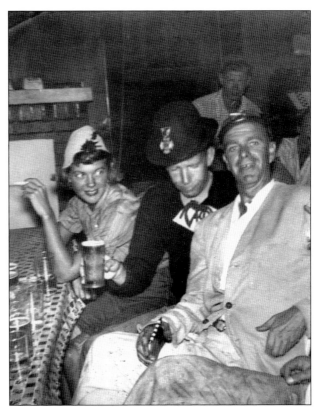

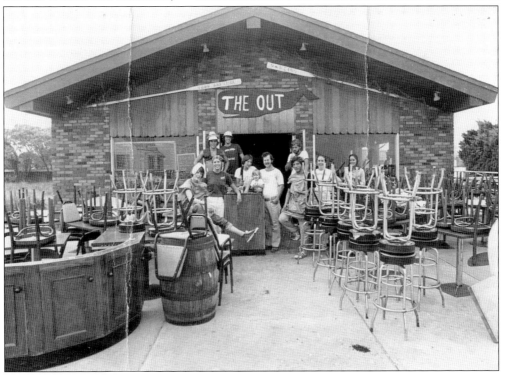

Fire Island residents are often self-made men and women; one was Arthur Lem. Born in China, Lem immigrated to the United States and became a popular restaurant owner, cookbook author, and ultimately a delegate at the Republican National Convention. Along with business partners George Helm and Alan Hathway, he was one of the developers of Lighthouse Shores in Kismet. Lem (pictured with Scott Barlow in 1968) entertained foreign dignitaries as well as members of the Kennedy family over the years, but he was known around Kismet for his outrageous sense of humor and as an avid fisherman. Below, his widow, Rose (center left), helps host the Arthur Lem Memorial Children's Snapper Fishing Tournament, an annual event held since his death in 1997. His story is truly that of the American dream on Fire Island. (Both, courtesy Lee and Warren Lem Collection.)

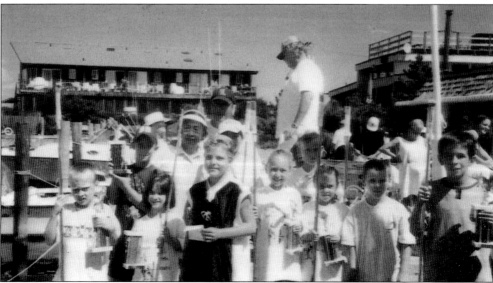

Five

WRATH OF STORMS

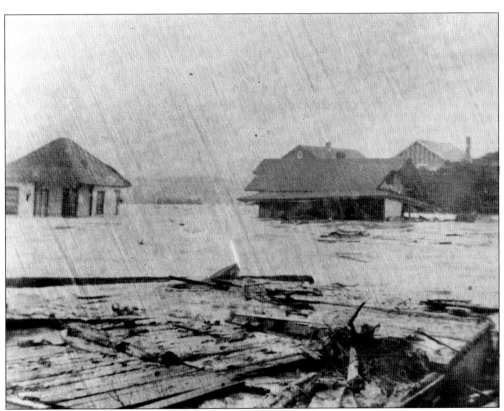

On September 21, 1938, a 13-year-old deaf girl named Muriel wandered outside Cherry Grove's Perkinson's Hotel with a simple box camera and created haunting images of the hurricane of 1938. Many stories would be told about this infamous day. Other storms landed on Fire Island in the decades to follow, some being the forces of nature, others the result of man. (Courtesy Donald Hester Collection.)

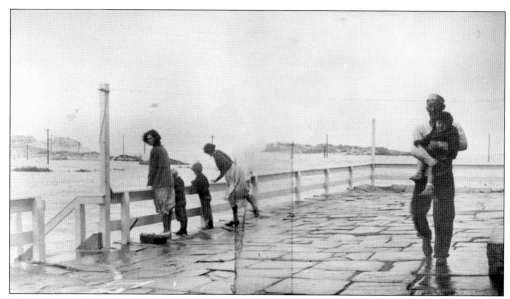

Electricity had been installed to replace kerosene as the power source for the Fire Island Lighthouse on September 20, 1938, only for it to be wiped out the very next day. On the stone deck of the lighthouse, keeper Roy Wood and his family survey the damage in the storm's aftermath. (Courtesy Luke Kaufman Collection.)

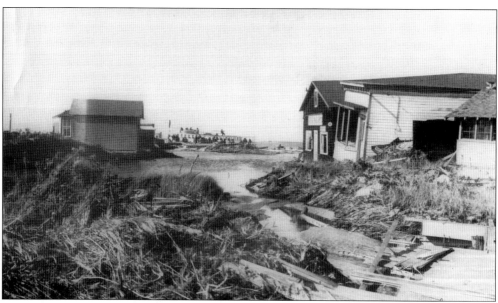

The hurricane made landfall at about 3:00 in the afternoon with winds gusts of up to 120 miles per hour and a 30-foot storm surge. In Fair Harbor, only eight houses would be left standing once the storm had passed, making it among the hardest hit of Fire Island communities. Behind the Pioneer Market in this photograph, people can be seen taking refuge aboard the *Atlantic*. (Courtesy Frank Mina Collection.)

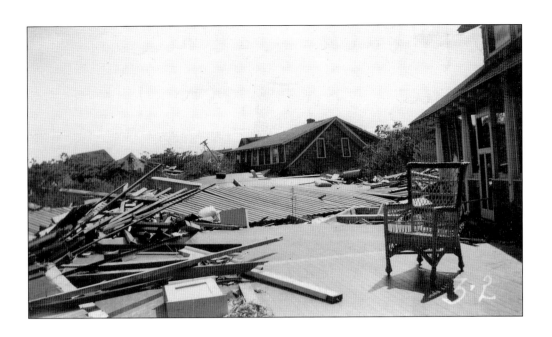

In order to provide scenic ocean views and easier beach access, planners of Saltaire and Cherry Grove had leveled the sand dunes. This decision would have tragic consequences as they suffered greater damage than neighboring Fire Island communities that had kept their natural dunes intact. Four people on Fire Island would lose their lives to the storm that day. Ocean Beach resident Wallace Pickard uncovered one of the bodies in Saltaire, recalling, "A number of us had been deputized for police duty because of the looting. You know in the bay where there would ordinarily be water, three or four feet of water? Well that part of the bay was filled with debris—you could *walk* on the debris. We found her there under a mattress." (Above, courtesy Frank Mina Collection; below, courtesy Donald Hester Collection.)

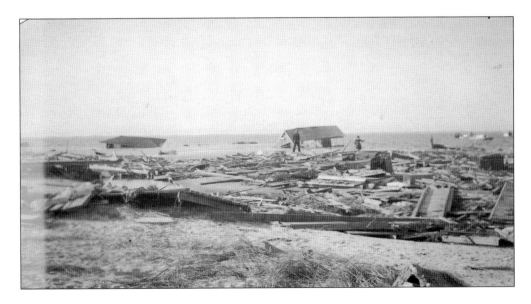

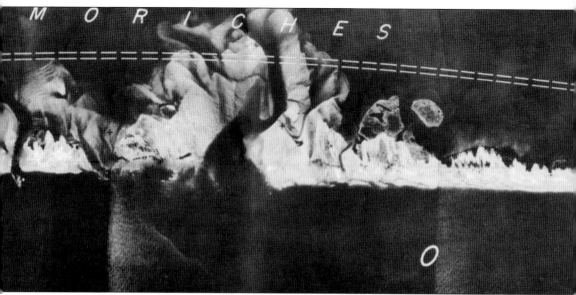

Storms cut inlets that have opened and closed naturally on Long Island's south shore barrier islands for centuries. The first signs are tidal over wash that can evolve into breaches where bay and ocean waters touch. If the storm is powerful enough, then inlets can form, breaking the landmass. Moriches Inlet, broke through by a nor'easter storm in 1931, widened substantially over the following years. Fire Island was now detached from the mainland for the first time in 50 years. The hurricane of 1938 formed 11 inlets on Long Island's south shore, but Moriches began to close again. County Public Works projects swiftly filled all but one, the Shinnecock Inlet out east. Together, Moriches and Shinnecock Inlets changed the salinity of the bays, making them an ideal habitat for Long Island's famous clams. Both inlets were deemed beneficial for navigational purposes as well as for the fact that they helped flush out pollutants from the duck farms, which were then common on eastern Long Island. The inlets were stabilized and regularly dredged, as they still are today. (Courtesy Warren James Collection.)

Insurance adjusters from National Liberty Company along with Saltaire resident Mike Coffey inspect post-storm damage. When coastal storms hit Fire Island in the 1800s, shipwrecks had been the primary concern. The hurricane of 1938 brought with it the realization that now there were millions of dollars worth of houses and infrastructure at stake as well as human loss on a much larger scale. (Courtesy Frank Mina collection.)

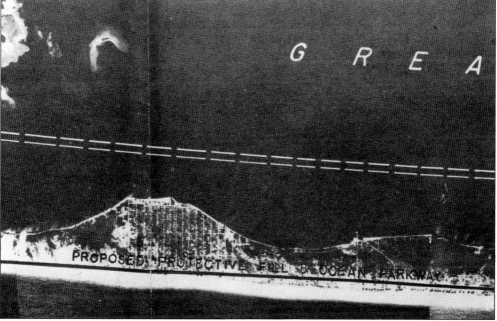

Ideas of building a road through Fire Island had been around since the late 1920s. Weeks after the hurricane of 1938, Long Island State Park commissioner Robert Moses made a lavish presentation to restore Fire Island by virtue of constructing a parkway, but the proposal did not succeed due to lack of funding. Note in the map detail that foundation fill is being described as "protective." (Courtesy Luke Kaufman Collection.)

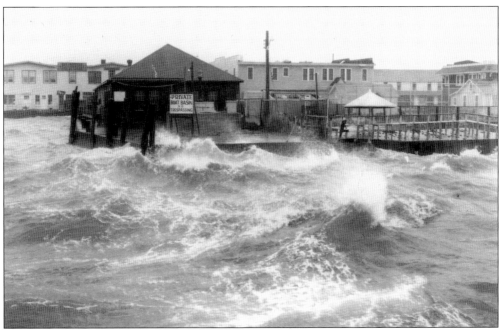

Other hurricanes would assault Fire Island over the years, including the Great Atlantic Hurricane of 1944, Hurricane Carol in 1954, and Hurricane Donna in 1960 as well as many unnamed nor'easters. All caused their share of damage. Coastal storms stir up the ordinarily peaceful bay, as can be seen in this c. 1950 photograph of the Ocean Beach ferry basin. If the storms hit during a full moon or high tide, significant flooding can also occur, as this late-1940s photograph below, also of Ocean Beach, clearly shows. Fire Islanders largely endured such turbulent waters, almost as if it were a trade-off for the glorious summer days offered in return. (Both, courtesy Frank Mina Collection.)

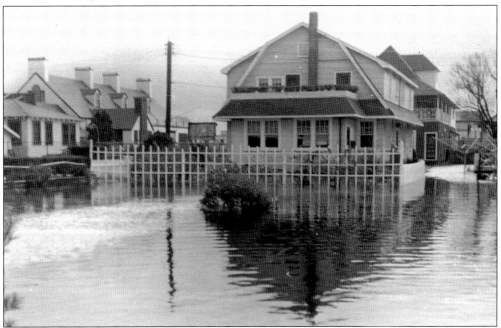

Talk of building a road on Fire Island had been around for decades but never gained serious momentum. In April 1954, the two-lane bridge of what was then called the Captree Causeway was opened to the public, with construction of an additional bridge farther south over Fire Island Inlet under way. Farther east, a footbridge known as Tangier Bridge had once existed at Smith Point at the turn of the century but was destroyed by ice flows and never rebuilt. In 1955, the Shirley-Mastic Chamber of Commerce broke ground for the construction of a drawbridge, which was part of a larger plan to develop a county park. The existence of these bridges made the prospect of a road that much more realistic, and it had the potential to change everything. (Above, courtesy Babylon Village Historical Society; below, courtesy Frank X. Fischer Collection.)

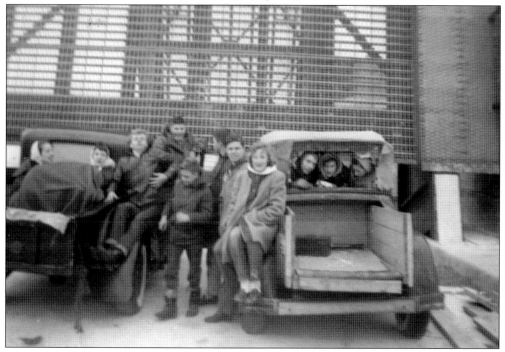

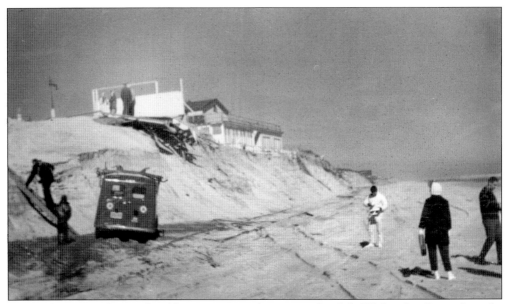

In March 1962, a slow and stubborn nor'easter known as the Ash Wednesday Storm brought significant destruction to the beach. Some 230 houses along the ocean side of Fire Island either littered the beach like broken matchsticks or were simply washed out to sea. Pictured are views of Davis Park and Ocean Beach, but every community suffered its share of casualties. In response to the event, Gov. Nelson Rockefeller organized a task force called the Temporary State Commission on Protection and Preservation of the Atlantic Shore Front and appointed Robert Moses as its secretary. He seized the opportunity to revive his vision of a paved road, and this time the plan was unveiled as a four-lane highway. (Above, courtesy NPS, Fire Island National Seashore; below, courtesy Maurice Barbash Collection.)

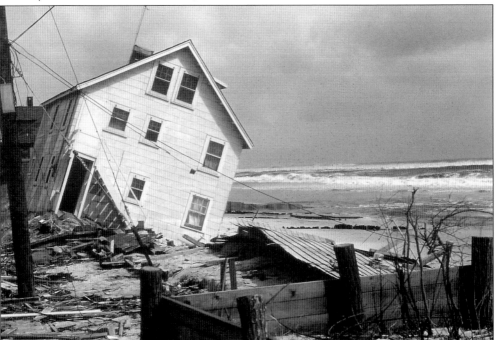

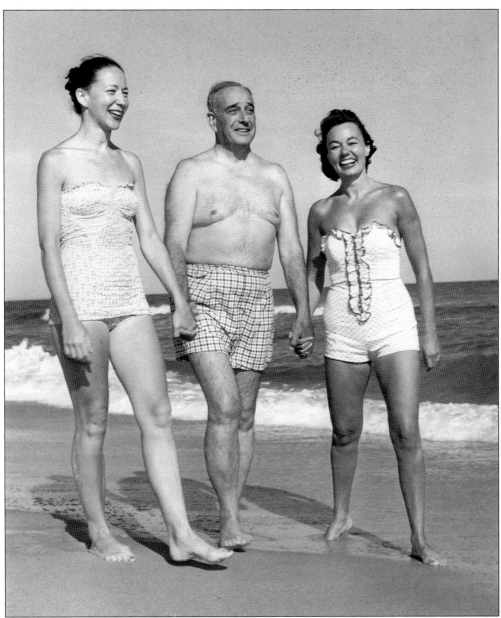

Robert Moses was a man of considerable influence and irony. He had held numerous public and powerful titles simultaneously, including chairman of the Triborough Bridge and Tunnel Authority, head of the New York State Power Authority, and his decades-old tenure with the Long Island State Park Commission—yet he never won a single elected office. He oversaw major projects that shaped the face of New York, including the Verrazano-Narrows Bridge, the Niagara Power Dam, and Long Island Parkway system, but he did not hold an engineering degree or even a driver's license. He was a man who knew what he wanted, but his dream of a shoreline parkway extending from Staten Island to Montauk Point evaded him for much of his career, due in part to a consistently stubborn group of holdouts on the barrier beach known as Fire Island. The beauties that accompany him in this c. 1960 promotional photograph have not been identified. (Courtesy Babylon Village Historical Society.)

The campaign to preserve Fire Island was an organized resistance that began as early as 1955 with the founding of the Fire Island Erosion Control Committee by Gilbert Serber of Seaview. As its name indicates, they lobbied for beach erosion and hurricane protection. The mission expanded, and the group was renamed the Fire Island Voter's Association in 1961 with Arthur Silsdorf, then mayor of Ocean Beach, as its first president. This organization exists today as the Fire Island Association. The future Fire Island Association did not battle alone. Once the road escalated into an all-out war by 1962, the Citizen's Committee for a Fire Island National Seashore was created. The residents of Fire Island knew what had to be done and that the time for action had arrived. (Above, courtesy NPS, Fire Island National Seashore; below, courtesy Maurice Barbash Collection.)

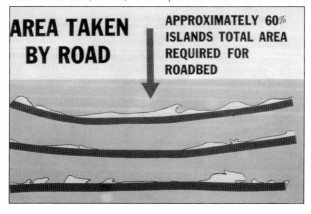

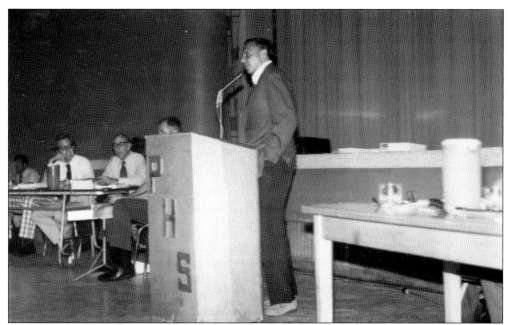

"The secret of our success was that most of our members of were not Fire Islanders," recalls the former chairman of the Citizen's Committee for a Fire Island National Seashore, Maurice Barbash of Dunewood. He adds, "We shifted the fight from Moses versus Fire Island residents to Moses versus conservation." With a carousel full of slides, Barbash made presentations at various locations, such as Patchogue High School, to diverse groups, including the Suffolk County League of Women Voters and assorted Long Island chambers of commerce, to garner support. The committee also traveled to Washington, DC, and secured the backing of then secretary of the interior Stewart Udall as well as the support of 1st New York District congressman Otis Pike, who had not initially been in favor of the concept. (Both, courtesy Maurice Barbash Collection.)

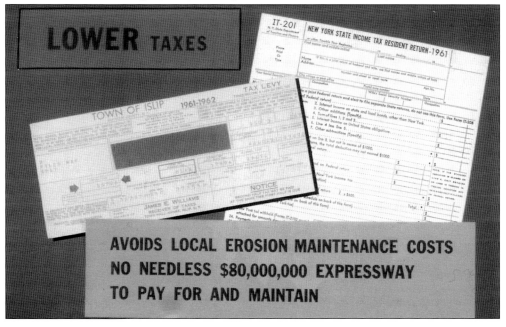

National Park Service
U.S. Department of the Interior
NPS Photo by M. Woodbridge Williams
192-1255

Sand dunes and beach grass...less than 40 miles from New York City lies the
undisturbed natural environment of Fire Island National Seashore. Although easily
reached by private boat or commercial ferry, the National Seashore still offers
opportunities for enjoyment and contemplation in relative solitude.

FIRE ISLAND
National Seashore

"For the purpose of conserving and preserving for the use of future generations certain relatively unspoiled and undeveloped beaches, dunes, and other natural features within Suffolk County, New York which possess high values to the nation as examples of unspoiled areas of great natural beauty in close proximity to large concentrations of urban population, the Secretary of the Interior is authorized to establish an area to be known as the 'Fire Island National Seashore'," reads the enacting legislation signed by Pres. Lyndon B. Johnson on September 11, 1964. Six prior bills had been introduced by Congress since 1958, and all had died on the floor. The version introduced by Otis Pike on June 18, 1963, would ultimately prevail. As refinements to the bill continued for another year, the bridge connecting Fire Island to the Captree Causeway was completed, and Fire Island State Park was renamed in honor of Robert Moses. By then, Moses had resigned from his post as Long Island State Parks commissioner on November 28, 1962. Gov. Nelson Rockefeller accepted it "with regret." (Courtesy NPS, Fire Island National Seashore.)

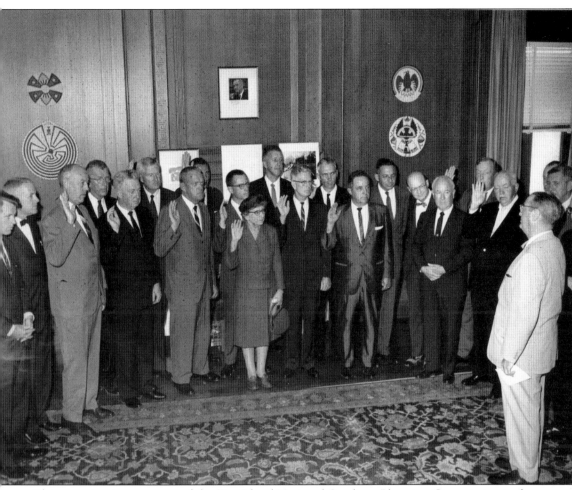

This swearing-in ceremony of the Fire Island National Seashore Planning Commission took place the following year on August 18, 1965, in Washington, DC. The purpose of this unsalaried committee was to "advise and consult with the Secretary of the Interior . . . on plans and activities leading up to the formal establishment of this addition to the National Park System." From left to right are Sen. Robert Kennedy, Congressman Otis Pike, Thomas J. Harwood, Hamilton Potter, Alvin Edwards, Dr. Robert Cushman Murphy, Charles Dominy, chairman George Biderman, Peter Costigan, Florence Baker, Robert Brewster, M. Scudder Griffing, William Sterling, Bruno Reciputi, Maurice Barbash, Northeastern Park Service regional director Ronald Lee, first parks superintendent Henry Schmidt, Everett Rattray, and Murray MacElhinny. Interior director of management operations N.O. Wood is administering the oath with National Park Service director George Hartzog, assistant secretary Stanley Cain, and undersecretary of the interior John Carver Jr., presiding. (Courtesy NPS, Fire Island National Seashore.)

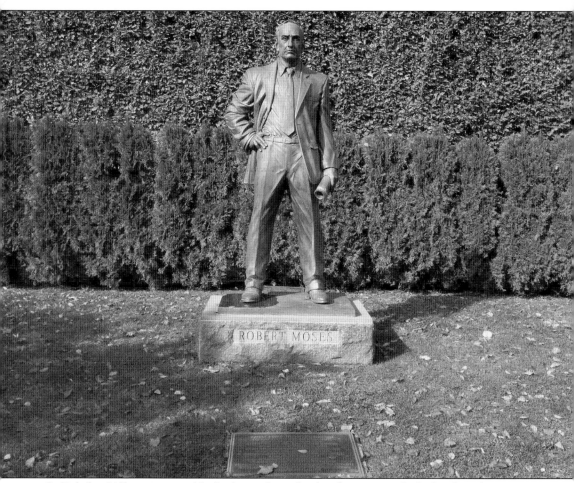

In Babylon Village, not terribly far from where the ferryboats once docked to board passengers bound for the Surf Hotel over a century ago, stands a bronze statue in tribute to Robert Moses. The plaque before it reads: "Robert Moses, (1888–1981), was responsible for more building than any single person since the pharaohs ruled Egypt. Between 1924 and 1968, Moses was the dominant and sometimes controversial force in the creation of extraordinary public works in New York City and New York State. A resident of Thompson Avenue in Babylon Village Moses is world renowned for creating the modern concepts of the state park and super highway. With an eye to the future, Moses preserved the integrity of the Long Island shoreline while creating a legacy for future generations." In truth, Fire Island was but one of many confrontations that would lead to his waning power. *Newsday* reporter Leonard Baker once called Moses "the real father of Fire Island National Seashore." He may well have been correct. This sculpture was created by Jose Ismael Fernandez. (Photograph by author.)

Six

Fire Island National Seashore

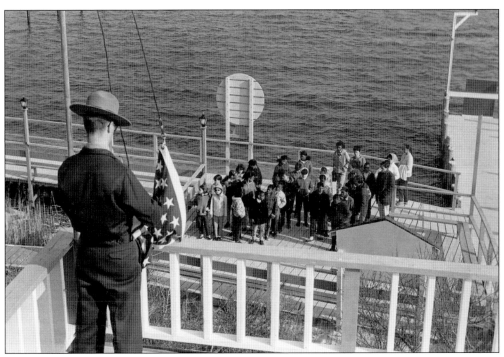

The vernacular acronym for Fire Island National Seashore is FINS. Fire Island was now part of the National Park Service, keeping company with the Grand Canyon, Yosemite, and Cape Cod, which had been declared a National Seashore only two years prior. It was a fresh start, but how would the Fire Island communities adjust to this new neighbor? (Courtesy NPS, Fire Island National Seashore.)

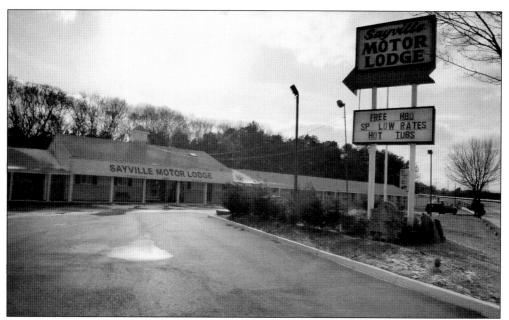

A few rooms were hastily rented in the Sayville Motor Lodge to serve as the official offices of Fire Island National Seashore in October 1964, and Henry G. Schmidt was appointed as the first FINS superintendent. Their permanent administrative headquarters was opened at Laurel Street in Patchogue, New York, 12 years later. (Photograph by author.)

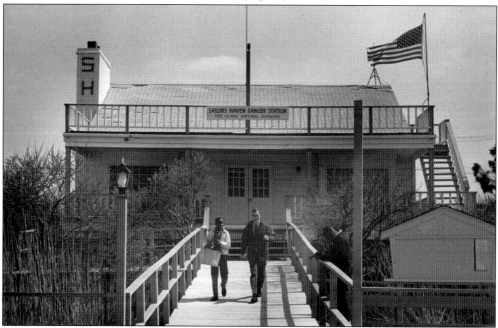

Establishing facilities to make the island more accessible to the general public was the first order of business for the Fire Island National Seashore. Sailor's Haven Visitors Center is located at the heart of Fire Island. In 1960, a private developer had planned to introduce Sailor's Haven as a residential community geared towards boating enthusiasts, but the enterprise was later abandoned. FINS acquired the property in 1966. (Courtesy NPS, Fire Island National Seashore.)

The original Sailor's Haven Company development proposal included efficiency apartment units, a tennis court, and a 100-slip marina, among other amenities. Much of this was never undertaken. By 1967, what was to be a yacht club became a visitor center, the apartments a staff-housing compound, and the scaled-back marina offered 45 slips for public use. (Courtesy NPS, Fire Island National Seashore.)

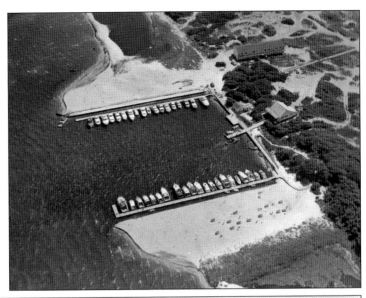

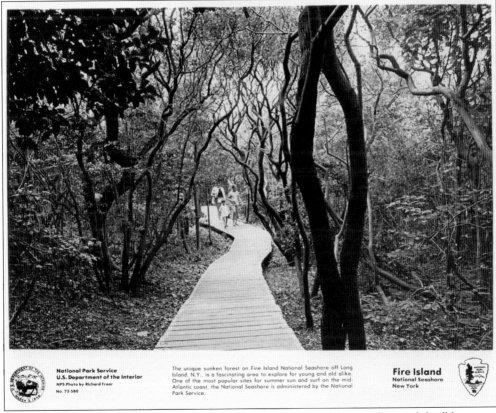

National Park Service
U.S. Department of the Interior
NPS Photo by Richard Frear
No. 73-580

The unique sunken forest on Fire Island National Seashore off Long Island, N.Y., is a fascinating area to explore for young and old alike. One of the most popular sites for summer sun and surf on the mid-Atlantic coast, the National Seashore is administered by the National Park Service.

Fire Island
National Seashore
New York

The Sunken Forest is a primeval maritime forest comprised of holly, sassafras, and shadblow trees. Protected by the dune system, a phenomenon known as "salt spray pruning" maintains forest growth at consistent heights. Campaigns organized in the 1950s to preserve Sunken Forest signaled early Fire Island resistance efforts. The property was transferred to FINS in 1966. Adjacent to Sailor's Haven, the two are managed together. (Courtesy NPS, Fire Island National Seashore.)

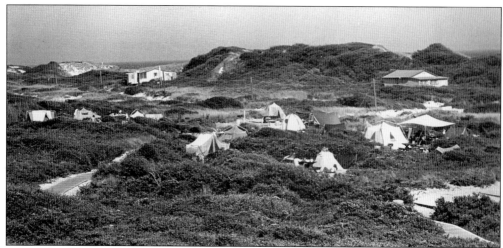

Watch Hill is the largest and most extensive of the Fire Island National Seashore facilities located within the designated area east of Davis Park. It was opened to the public in 1967 with a 166-slip marina and the only FINS facility to offer campgrounds. Over the decades, Watch Hill has been gradually upgraded to include a souvenir stand, snack bar, visitor center, restaurant, and additional nature trails. The marina has been expanded to accommodate as many as 183 boats with water and electricity hookup service. Additional facilities include Talisman/Barrett Beach and Old Inlet, which have no ferry service so are accessible via private boat only. If the Sailor's Haven/Sunken Forest facility is considered the "crown jewel" of FINS, then certainly Watch Hill is its flagship. (Both, courtesy NPS, Fire Island National Seashore.)

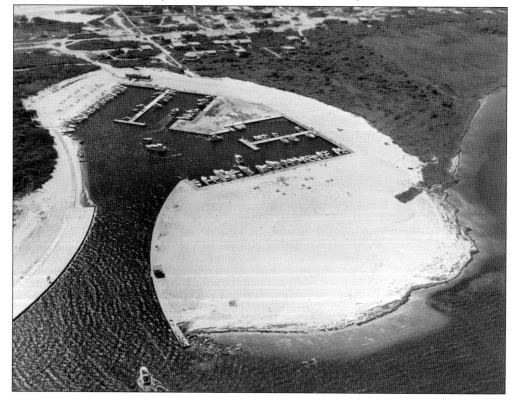

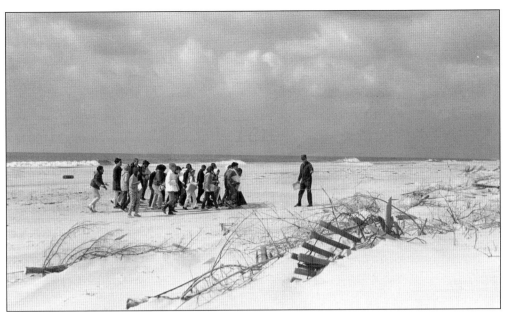

One distinct change upon the arrival of FINS was the presence of National Park Service rangers on Fire Island. Rangers are entrusted to maintain the peace in all national parks but are also responsible for the interpretation of resources. Ranger-led nature tours soon became a common sight in many areas of Fire Island. Equestrian patrols have also been utilized, especially on the eastern end of Fire Island where use of motorized vehicles may not always be possible or practical. Rangers are often the first point of contact for visitors and therefore the official face of Fire Island. (Both, courtesy NPS, Fire Island National Seashore.)

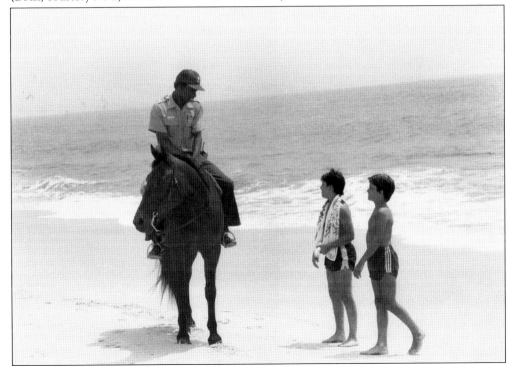

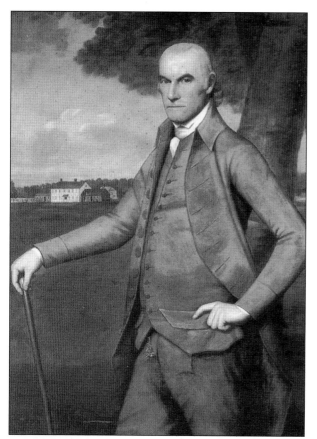

Historic and cultural preservation also falls under the National Park Service mandate, and one charge would come to FINS from an unexpected place. Since William Floyd was the only signer of the Declaration of Independence who resided in Suffolk County, the significance of his 610-acre family homestead being gifted to the US Department of the Interior in 1965 went unquestioned. Yet the decision to annex it to FINS jurisdiction is somewhat surprising because the William Floyd Estate is not located on Fire Island, but across the bay on Greater Long Island in Mastic Beach, New York. The original 1792 portrait of William Floyd by Ralph Earl (left) now hangs in Independence National Historic Park in Philadelphia, Pennsylvania. (Both, courtesy NPS, Fire Island National Seashore.)

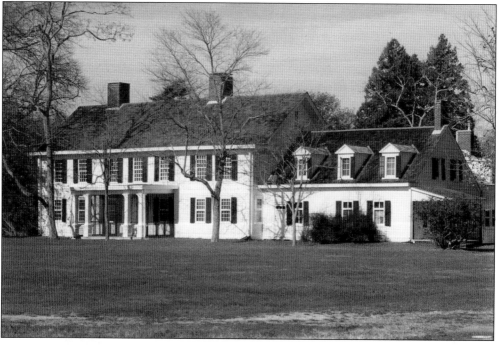

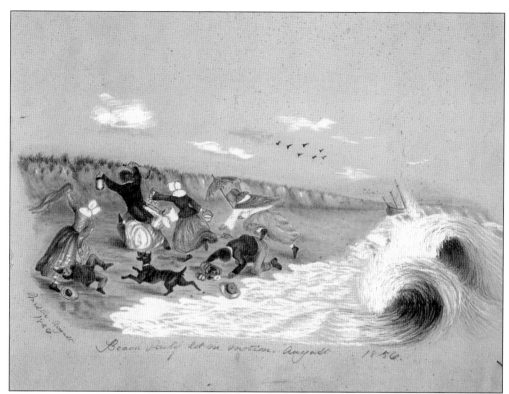

The annexation of the William Floyd Estate was really not that much of a reach. Both were part of William "Tangier" Smith's 1693 colonial land grant, and the family maintained a close relationship with Fire Island. The artwork from a teenage Katherine Floyd Dana depicts whimsical scenes of Fire Island life in the 1850s. The c. 1898 photograph at right shows Cornelia Floyd Nichols, wearing the hat, looking on in the background at this family picnic near Smith Point. Note how much the man on the left resembles his ancestor. Floyd family descendants occupied the estate until 1976, when the agreed upon 25-year lease expired. Terms of the agreement still allow members of the Floyd family burial rites in their ancestral cemetery on estate grounds upon death. Since 1980, the Floyd Estate has been a public museum, open May through October. (Both, courtesy NPS, Fire Island National Seashore.)

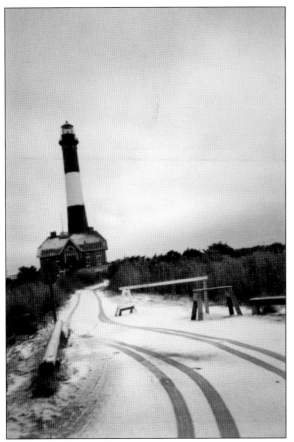

On December 31, 1973, Fire Island Lighthouse went dark. It was officially decommissioned when a strobe light was installed atop the nearby Robert Moses State Park water tower. With inactivity, the 120-year-old lighthouse began to show its age. In 1979, the lighthouse tract was transferred from US Coast Guard to National Park Service ownership and only allowed protective measures against looting and vandalism. By 1981, the decaying structure was deemed unsafe and targeted for demolition. Residents on both sides of the Great South Bay were not about to give up their beloved lighthouse so easily, and a grassroots campaign was under way. The Fire Island Lighthouse Preservation Society was formed in 1982 to restore the lighthouse to its former glory. (Left, courtesy John McCollum Collection; below, courtesy NPS, Fire Island National Seashore.)

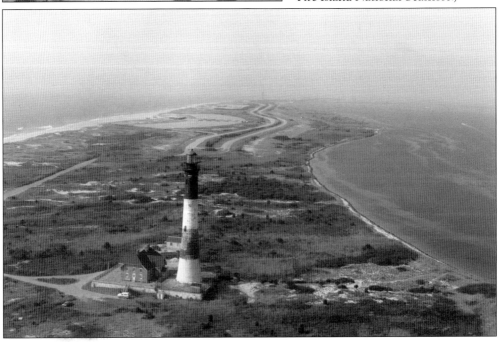

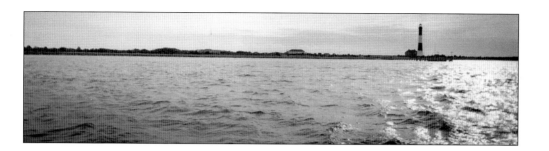

Advances in navigation safety have perhaps made the lighthouse keeper's job of manning the beacon unnecessary, but the argument to preserve the Fire Island Lighthouse was not just sentiment. The Robert Moses water tower strobe did not illuminate the bay-side waters. Support was just as strong among local baymen as it was with historical preservationists. After more than a century of safeguarding lives, it was the lighthouse's turn to be saved. It was entered in the National Register of Historic Places in 1984, and the beacon was relit in 1986. The keeper's quarters opened as a public museum and education center three years later. It is now one of the most visited lighthouses in the nation. Pictured below are Louis Bejarano (left) and president of Fire Island Lighthouse Preservation Society, Thomas Roberts III. (Both, courtesy NPS, Fire Island National Seashore.)

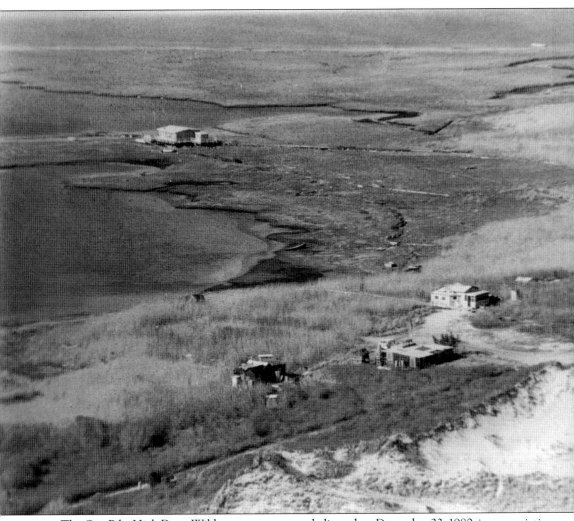

The Otis Pike High Dune Wilderness area was so dedicated on December 23, 1980, in appreciation of the former congressman who championed the FINS enacting legislation almost two decades earlier. The 1,380 acres is some of the last tracts of undeveloped barrier island along the north East Coast. It is the only Federal Wilderness Area in New York and one of the smallest in the country. With its beauty comes a legacy of controversy. The residential communities that were within Fire Island's boundaries, but predated establishment of FINS, were exempt from condemnation. Houses within the wilderness area, however, did not enjoy such protection. Like the descendants of William Floyd, the 41 affected homeowners were offered options that included purchase, 25-year leases, or lifetime leases. Some pursued legal action, albeit unsuccessfully. By 1992, the last of these leases expired. The land parcels on which these homes once stood were brought back to their natural state. (Courtesy NPS, Fire Island National Seashore.)

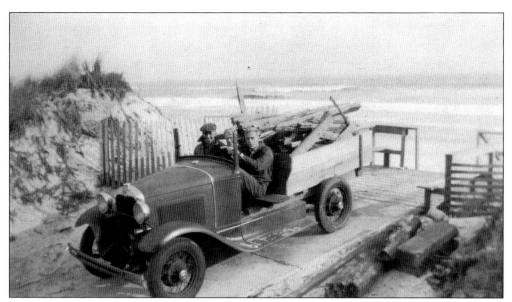

A major impetus behind FINS was a desire that there never be a paved roadway on Fire Island, but automobile driving long held a place within the island's culture. Federal motor vehicle regulations on Fire Island date back to 1968 and became increasingly stringent over the following decades. Soon the question emerged: What was appropriate and environmentally sound off-road vehicle utilization on Fire Island? "If people must have the convenience of an auto, let them go to Atlantic City or the Indianapolis 500," wrote Gerard Doff when public comment was opened on the subject. In 1978, Fire Island residents Bea Thornberg, Walter Reich, and John and Jane VanCott traveled to Washington, DC, to join others who lived within national parks throughout the country to rally for the right to drive. (Above, courtesy Dale Wycoff Collection; below, courtesy Jane VanCott Collection.)

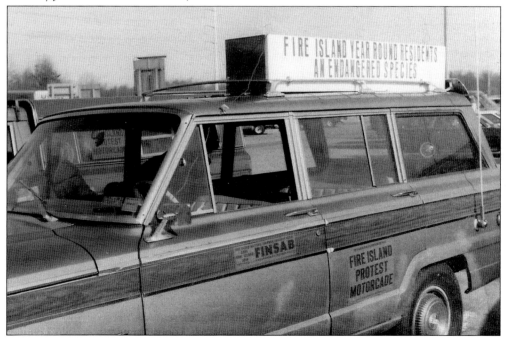

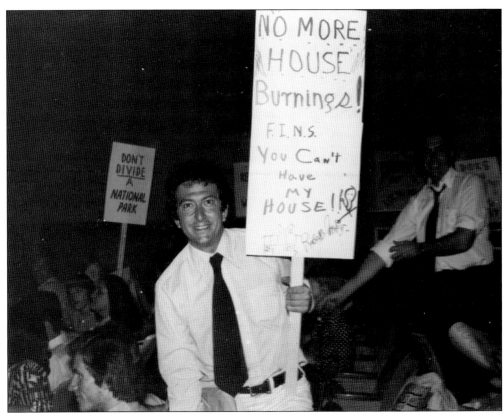

In 1975, FINS proposed a draft master plan that included many drastic changes, such as moving the western boundary of its jurisdiction to Point O'Woods, transferring ownership of the lighthouse tract to Robert Moses State Park, and creating a paved bicycle path between Point O'Woods and Moriches Inlet. It was met with hostility when presented for public comment. That year, Richard Marks took office as superintendent. More than just removing unpopular proposals, he retooled the process to encourage public involvement at ground level. This "General Management Plan," signed in 1978 by regional director Jack Stark, would set a concept model for national parks across the country. FINS and the Fire Island communities would still have their differences from time to time, but this was a partnership destined to endure and grow. (Both, courtesy NPS, Fire Island National Seashore.)

Seven

NATURE IN THE BALANCE

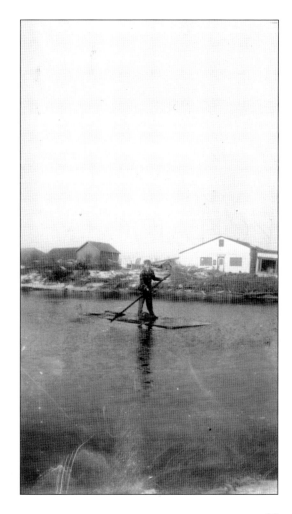

Warren James navigates the over wash in a raft made from a scrap of boardwalk after the hurricane of 1938. Obtaining National Seashore status did not mean conservation concerns were an issue of the past for Fire Island, rather, far from it. In some ways these matters had become increasingly more complicated as man and nature mixed on this fragile barrier island and environmental pressures grew ever more precarious. (Courtesy Warren James Collection.)

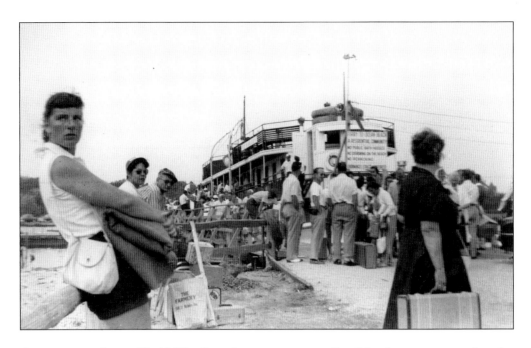

Gas rationing during World War II made vacationing on Fire Island attractive to a broader audience. With the postwar economic recovery, this surge of patronage continued to increase. At the height of the summer, riders filled the ferries. Mainland terminal parking lots were packed. Pedestrians crowded the boardwalks, and the island's white sandy beaches were bustling. Some Fire Island communities reacted by enforcing stringent "codes of conduct" to their visitors and residents. Some of the regulations posted at the Ocean Beach–bound terminal included no ball playing on the beach, no eating on public walks, and no bicycle riding. With such tough rules, the community was soon dubbed "The Land of No." (Both, courtesy Frank Mina Collection.)

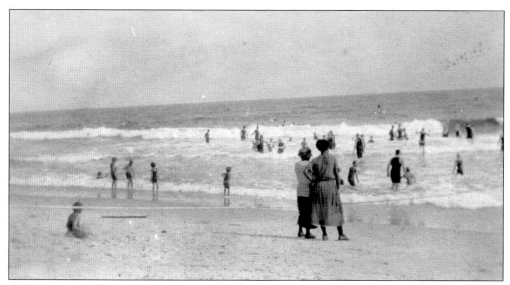

A comparison of the c. 1910 photograph above of the Ocean Beach/Seaview area with a c. 1990 photograph below of Sailor's Haven beach illustrates the typical oceanfront scene roughly three-quarters of a century apart. They each represent respectable beach attendance, but the photograph below shows beachgoers assembled in orderly rows, which is a sign that ground capacity is strained. Of course, beach attendance fluctuates depending on the weather, and some Fire Island communities enjoy more seclusion than others. Available statistics from the National Park Service visitor centers suggest that recreational visitor averages have more than doubled over 40 years and is probably higher among the communities. (Above, courtesy Dale Wycoff Collection; below, courtesy NPS, Fire Island National Seashore.)

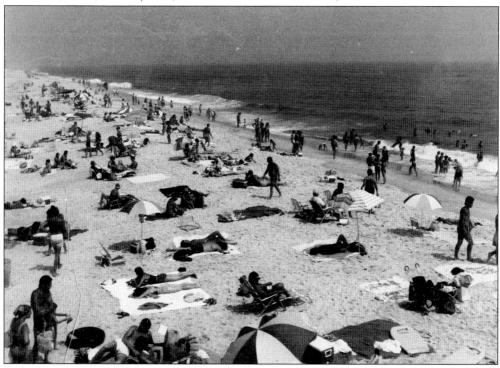

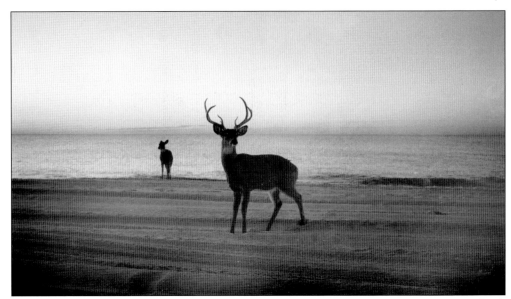

The robust white-tailed deer population is an endless source of wonder for newcomers to Fire Island, but the deer's large presence is a development that only took hold within the last 30 years. It is uncertain exactly how the deer came to Fire Island, but they may have walked across frozen bay waters in the winter months. As beautiful and majestic as the deer are, they do not necessarily mix well in residential areas. They are unwelcome guests in gardeners' flower beds and scavenge through garbage pails, becoming a nuisance. They are also a source of divisiveness. Some groups believe the deer herd should be culled, a notion which is repugnant to others. (Above, courtesy Luke Kaufman Collection; below, courtesy Frank X. Fischer Collection.)

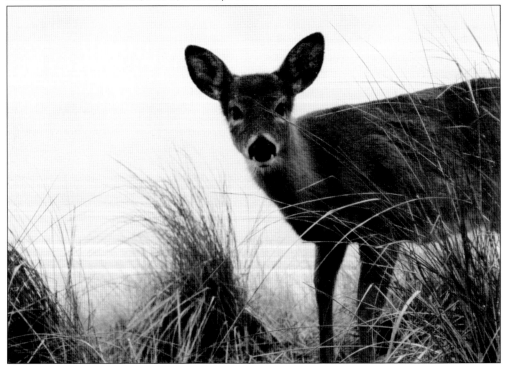

In 1999, a doe gained local notoriety in the Ocean Beach/Corneille Estates communities when she got her head caught in the opening of a recyclable can receptacle lid. For weeks, she wore the lid around her neck like an Elizabethan collar with her twin fawns in tow. While she was certainly managing, her long-term welfare remained a source of concern. She had also become a public relations nightmare for Fire Island at the height of tourist season. After a number of unsuccessful attempts to extract the lid by good Samaritans and the ASPCA, the Department of the Interior brought in skilled sharpshooters from Louisiana who anesthetized her with a dart tranquilizer and successfully removed the lid. This story had a happy ending; unfortunately, not all of them do. (Photographs by John McCollum.)

Where charming Fire Island cottages once stood, "McMansions" are systematically replacing them. While all architecture is a matter of personal taste, these significantly larger homes consume more energy, which strains the power grids that service Fire Island. Such structures have greater building lot ratio footprints and hamper natural drainage, thus collectively contributing to flooding issues. Clear-cutting of foliage in order to construct such houses is also common practice. While Fire Island National Seashore may raise objection to building applications, towns and villages issue permit variances almost routinely. Despite this, it is big business for Fire Island, since real estate brokers, builders, and the municipalities themselves all generate revenue from the practice. Yet each time such a house is built, another piece of Fire Island is taken away. (Above, courtesy Ocean Beach Historical Society, Wallace Pickard Collection; below, photograph by author.)

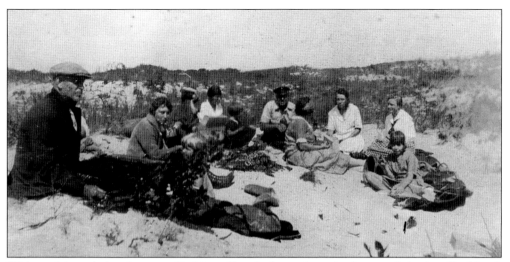

With sand dunes being the natural habitat of beach plums, these shrubs once thrived on Fire Island, as did blueberries in the late summer months. Overdevelopment and the planting of ornamental, invasive plant species have depleted resources of such precious native flora. The practice of clear-cutting property lots to erect structures quickly devastates the Fire Island ecosystem. Such ground cover is typically replaced by inappropriate choices, such as bamboo, which, with their aggressive root systems, choke out other shrubs and offers no food or shelter to bird populations. While some Fire Island communities have passed "bamboo ordinances" and other legislation to address the concern, they are rarely enforced. Now wild blueberries are harder to come by every year, and the beach plum is all but extinct around the Fire Island communities. (Both, courtesy Dale Wycoff Collection.)

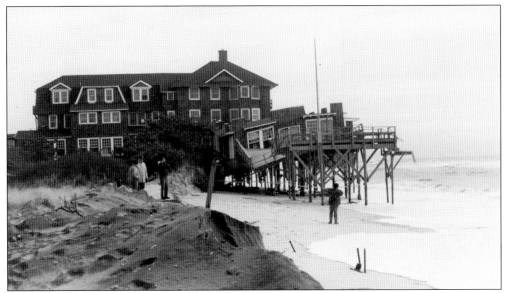

In the 1960s, it had been the hope of many Fire Islanders that, when National Seashore status had been achieved, it would at last break the deadlock for funding beach renourishment projects that so often lingered at state and county levels. Decades later, such promises—whether real or imagined—never materialized. Fire Island was then besieged by multiple unnamed storms in frequent succession during the years 1991, 1992, 1993, and 1996. Many oceanfront structures in multiple communities washed out to sea, and flooding was some of the worst in recent memory. If anything, the frustrated people of Fire Island now felt that the Fire Island National Seashore was not only of no help, but actually a hindrance to initiating shoreline protection efforts. (Above, courtesy NPS, Fire Island National Seashore; below, photograph by Frank X. Fischer.)

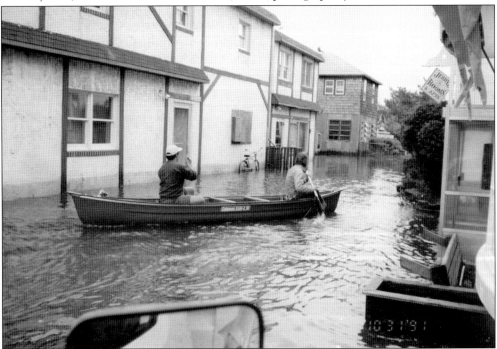

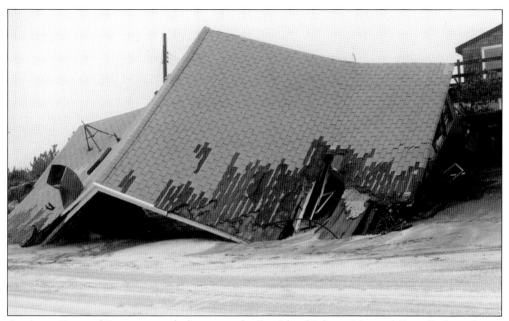

An Army Corps of Engineers study, known as the Fire Island Inlet to Montauk Point Reformulation Project (FIMP), has its roots as far back as 1958. In 1978, the Department of the Interior deemed that the original study had failed to examine the south shore barrier system as a whole and ordered it be redone. Conflicting positions among cost-sharing agencies further stagnated the process. (Courtesy NPS, Fire Island National Seashore.)

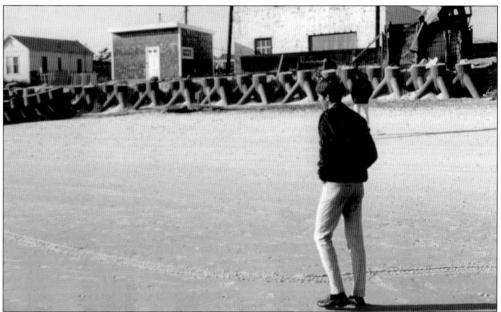

After the nor'easter of 1962, Ocean Beach undertook an ambitious project of installing cement "pods" into a system of beach groins in order to protect their water system and the beach itself. Considered state of the art at the time, such hard-structure approaches to manage beach erosion is now less favored by scientists due to the scouring effect surrounding areas may encounter. (Courtesy Luke Kaufman collection.)

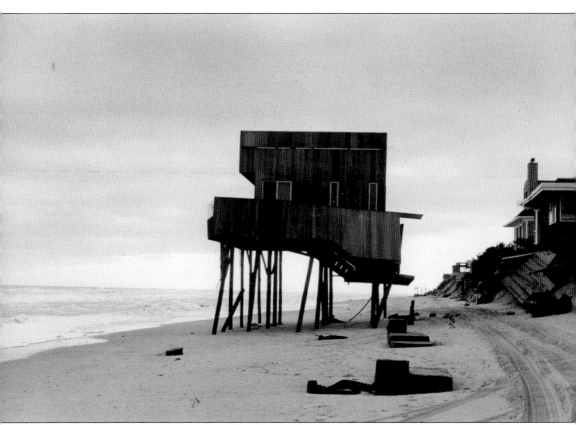

Fire Island remains exposed and vulnerable, even after more than 70 years have passed since the maiden dredging of the Moriches Inlet, which possibly interrupted the westward littoral drift of sand to Fire Island; 50 years after the abandoned original Army Corps of Engineers study of Long Island's south shore; and 30 years after the present Fire Island Inlet to Montauk Point Reformulation Project study, which remains incomplete, possibly into perpetuity. The houses built upon the island are not unlike delicate castles made of sand. Matthew 7:24–27 of the New Testament speaks of the wise and foolish builder, reading, "A foolish man, which built his house upon the sand: And the rain descended, and the floods came, and the winds blew, and beat upon that house; and it fell: and great was the fall of it." Had Fire Island been forsaken? (Courtesy NPS, Fire Island National Seashore.)

Eight

THE BUILDING BEACH

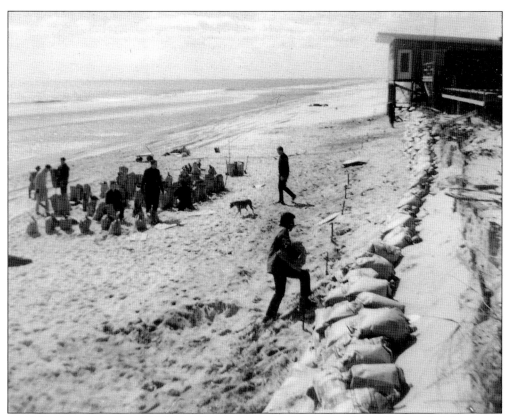

In 1962, the community of Cherry Grove came together to reinforce their eroded dune with sandbags. Dedicated groups and individuals on Fire Island have always strived to set matters that have gone astray back on the right path again, much like the sands that recede then replenish themselves over time. The island shifts accordingly—dynamic and renewing, fragile yet eternally resilient. (Courtesy Donald Hester Collection.)

With the FIMP study not necessarily closer to conclusion in 2008, Fire Island embarked upon a first time cross-community beach renourishment project. With almost two million cubic yards of sand dredged from offshore locations, 11 communities participated by pumping it onto five miles of coastline. Fire Islanders footed $25 million in costs hoping to address coastal erosion concerns. Below, senior coastal engineer Steven Keehn of Coastal Planning and Engineering of Boca Raton, Florida, leads a team of representatives to observe the progress. The project won a "Best Restored Beach" award by American Shore and Beach Preservation Association in 2009. Only time will tell how successful this undertaking will actually be, but it was applauded as a new era of cooperation between the communities, Fire Island National Seashore, and other entities. (Above, courtesy Fire Island Association; below, photograph by author.)

With 1978's General Management Plan now over 30 years old, it is time to replace the document. In 2006, Fire Island National Seashore mobilized to gather feedback from residents, visitors, and other stakeholder groups who have say in the destiny of this national park. "We need to know what works, what doesn't, what needs to change, and what should stay," said park planner Diane Abell, explaining the process. Pictured below, Fire Island Association representatives Susan Goldhirsch (second from left) and Joseph Loeffler Jr. (center), along with deputy superintendent Sean McGuiness (left), National Park Service community planner Ellen Carlson (right), and an unidentified man discuss Fire Island's GMP by-laws at a work session. Zoning, endangered species protection, and FINS facilities are some issues on the table; such a treatise takes years to compile. (Both, courtesy NPS, Fire Island National Seashore.)

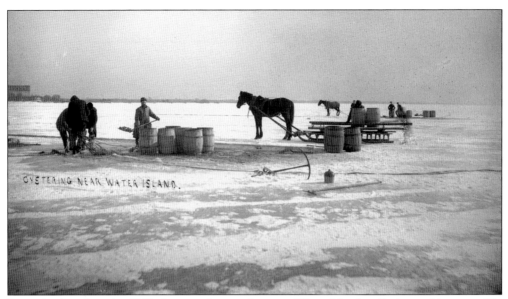

Since the day when this 1907 photograph was taken near Water Island, pollution and irresponsible harvesting have taken their toll on the once bountiful Great South Bay shellfish industry. Organizations like the Peconic Baykeeper are striving to protect the aquatic ecosystem of the South Shore estuary and other Long Island waterways through legal, scientific, and public education. The Baykeeper's accomplishments include a six-year litigation battle with Suffolk County to modify pesticide application practices for wetlands mosquito control, pressing New York to establish vessel sewage "No Discharge Zones" for commercial and recreational watercraft on the Great South Bay, and instigating mandated cleanup of the bay bottom after discovering battery-dumping practices by the US Coast Guard. With vigilance, perhaps bay health can be restored. (Above, courtesy Archives at Queens Library; below, courtesy Peconic Baykeeper.)

Understanding the need for cooperation between Fire Island's communities and the financial constraints of Fire Island National Seashore, the Fire Island Land Trust was founded in 2006. This nonprofit organization uses legal protocols such as conservation easements, land donation, and bargain land sale deeds to provide private Fire Island landowners options beyond shortsighted land development projects. It is the only local organization committed to protecting and preserving natural places and historic resources throughout Fire Island. The Land Trust is presently in partnership with the Fire Island National Seashore to help restore the Carrington Estate, which is west of Fire Island Pines. When owned by the famous Broadway producer Frank Carrington, the 20th-century compound had Katherine Hepburn, Henry Fonda, and Truman Capote among its guests. The home was purchased by the National Park Service in 1969 and has since fallen into a serious state of disrepair. The trust is assisting the National Park Service in an effort to stabilize and revitalize the buildings for productive use with the hope of eventually placing it in the National Register of Historic Places. (Courtesy NPS, Fire Island National Seashore.)

To address the needs of its wildlife, FINS sometimes partners with nonprofit agencies. Seeking humane alternatives to address Fire Island's expanding deer population, the Deer Immunocontraception Program was initiated in 1992 in cooperation with the US Humane Society and dedicated volunteer Fire Island residents. Pictured in Saltaire in 1995, Marija Beqaj and Rick Naugle are testing a prototype "marker dye" to be used with contraceptive darts delivered via blowgun. The Riverhead Foundation for Marine Research and Preservation, located on Greater Long Island, is also often called upon to aid distressed porpoises, sea turtles, and seals that land upon the shores in distress. These partnerships bring valuable expertise and often fill in where FINS resources might otherwise be overextended. Some of these programs are experimental, however, and results can be uneven. (Above, photograph by author; below, courtesy NPS, Fire Island National Seashore.)

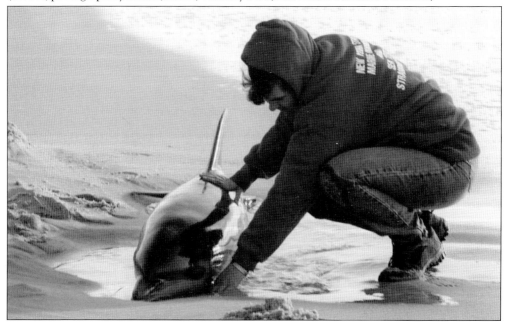

The improvised efforts of Fire Island's residents are never to be underestimated. The people who live here often have considerable knowledge as well as an intuitive connection to the island's inhabitants, whether four legged or feathered. They are also willing to step in where bureaucracy might otherwise not allow. Pictured above is Elaine Brewster of Atlantique with her goose, Chuckie. This particular animal rescue became Brewster's most loyal companion during the 1990s, when Chuckie gained considerable local notoriety for protecting his flock. Below, John McCollum is pictured c. 2000 drying off a young buck that had fallen into the bay. (Above, photograph by author; below, photograph by Frank X. Fischer.)

Above, a flock of terns take flight. Below, an American oystercatcher rests on the undeveloped islet known as East Fire Island, and the former Coast Guard Station that is now the Summer Club's meeting house stands faintly in the distance across the bay. Fire Island remains important nesting habitat for a variety of shorebirds as well as other animal species often on federal and state endangered or threatened lists. Without places like Fire Island, their fate would be far less hopeful. Fire Island was saved from a road envisioned by Robert Moses over a generation ago. Saving Fire Island from ourselves is the challenge that must now be met to insure its future. (Both, courtesy of Alainthomas.net Photography.)

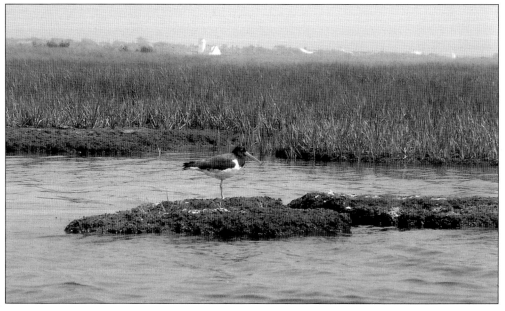

Nine

A BEACH HERITAGE

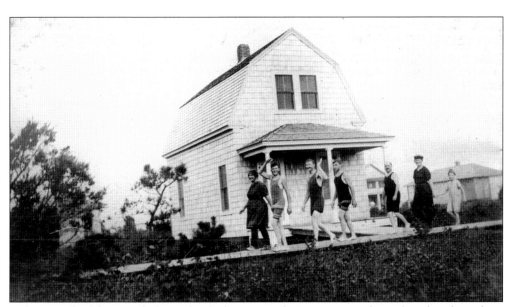

Perhaps much of the appeal of Fire Island is how uniquely American it is, being fiercely independent, unapologetically bold, and tenacious to the extreme. All islands are built over time from the ebbs and flows of the ocean tides, but Fire Island is a place where there are no barriers. (Courtesy Wallace Pickard Collection.)

In 1977, Ocean Beach bakery proprietor Rachel Doering found herself at the center of controversy when two teenage boys received a summons for eating cookies, purchased from her shop, on a public walk. She retained an attorney to defend her customers in court. The much-publicized incident drew attention from media outlets as far away as Israel and Japan, who focused upon the severity of the local ordinances of this village, nicknamed "The Land of No." The late Benjamin Mehlman, who presided over the case as Ocean Beach Village justice, wrote, "I received phone calls from CBS, and NBC actually had camera crews at the courthouse . . . I became known and still am recognized as 'The Cookie Judge'." The case was ultimately dismissed, and Ocean Beach subsequently relaxed this ordinance. Rachel still bakes her signature cookies and other baked goods to this day. (Photograph by author.)

Baseball games have been played in Seaview's Newman Field since summer 1973. As some American sport traditions endure, new ones have also been born on Fire Island. Over in Corneille Estates, a game known as Trangleball has been played almost every summer weekend on the beach for nearly two decades. Trangleball has concentric rings, a palm-sized ball, and its signature three-sided pyramid. Almost like a three-dimensional handball, the game is adaptable to multiple players and settings but always requires sharp skills, deft reflexes, and a dose of cunning. The tournaments never fail to attract a crowd. Since the patenting of Trangleball in 1993 by its inventor, Mark Miller, it has gained a following in countries as far away as Japan, France, and the Czech Republic. (Right, photograph by Warren C. McDowell; below, courtesy Jay Blakesberg and Trangle, Inc.)

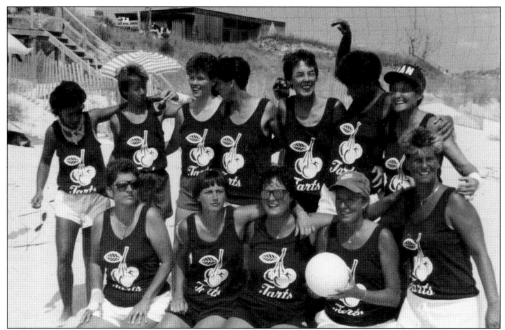

In 1984, Cherry Grove started organizing annual volleyball tournaments against the Suffolk County Police Marine Bureau, known as the Grovettes v. the Copettes. In a community where gays and lesbians once suffered their share of persecution by the police, these games are evidence of old prejudices being cast aside. (Courtesy Jan Felshin and Edrie Fedrun Collection.)

In 2004, the "Bishop" Harold Seeley escorts two protestors for gay marriage, which became legalized in New York in 2011. Like Provincetown and San Francisco, the communities of Cherry Grove and Fire Island Pines have broken new ground in the world of gay culture. (Courtesy Jan Jan Felshin and Edrie Ferdun Collection.)

What began as little more than a modest charity to purchase a truck for the Fire Island Pines Volunteer Fire Department in the 1970s soon escalated into the Morning Party, a major fundraising mechanism for the Gay Men's Health Crisis in response to the despair brought on by the AIDS virus during the 1980s and 1990s. Disco performers like France Joli launched her career at this all-night event. Renamed the Pines Party in 1999 and reinventing itself again as the Ascension Party in 2006, other charitable organizations began sponsoring the affair over time. The dance party remains unwavering in both spirit and spectacle. Generally held on the last Saturday during the month of July, this event is now considered to be the ultimate in summer revelry that Fire Island has to offer. Much more than a celebration of gay pride, it displays the sheer economic power the Pines can wield in support of causes it deems important. (Photograph by Warren C. McDowell.)

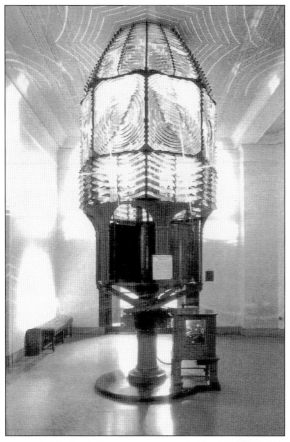

Preserving Fire Island's cultural and historic resources is an ongoing mission. One of the most recent challenges has been to bring the Fresnel lens back to its home at the Fire Island Lighthouse. This multi-prism first order lens (orders being measured in focal length) was as much a marvel of technology when it was installed atop the newly constructed lighthouse back in 1858 as it is today. Replaced in 1933, the lens was exhibited at the Franklin Museum in Philadelphia until 2000. On July 22, 2011, the Fire Island Lighthouse Preservation Society and the Fire Island National Seashore celebrated the official opening of a new building intended to display the lens so the public could view this magnificent object once again. (Left, courtesy NPS, Fire Island National Seashore; below, photograph by Joseph Lachat.)

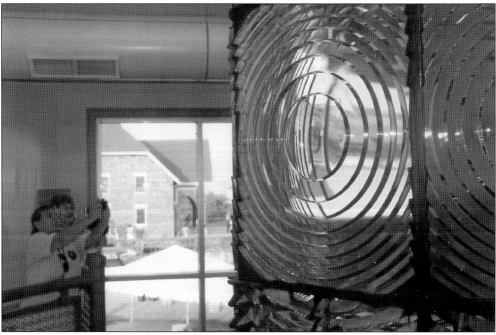

The Fire Island Lighthouse is much more than a tourist attraction. Over the past century, the lighthouse has remained a focal point of identity and culture for the people of Fire Island, even in the most lighthearted of fashions. Pictured at right, a young woman in Ocean Beach models her creation most likely before an Independence Day Parade around 1920. Pictured below, a mysterious masked man attends the Fire Island Pines Invasion Day, also on the Fourth of July. This choice of holiday is more than a coincidence—Fire Island represents a freedom of spirit worthy of such celebration. (Right, courtesy Dale Wycoff Collection; below, courtesy Cherry Grove Archives.)

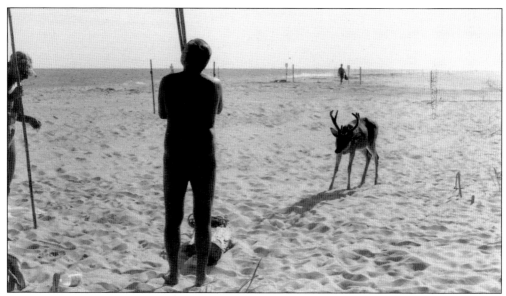

There are several "clothing optional" alternatives on Fire Island. Lighthouse Beach is one of the most popular nude beaches in the United States. Other secluded stretches, while not designated by Fire Island National Seashore for nude sunbathing, find it still generally tolerated, even by the local wildlife. (Photograph by author.)

Chet Whitehorn (right) won a sports car on the television game show *Concentration* in the 1960s and subsequently traded it for land in Davis Park with his friend, Hobby Miller (left). Clearly, both Miller and Whitehorn understood that fancy cars may come and go, but good times shared with friends on Fire Island last forever. (Courtesy Jud Whitehorn Collection.)

Steven Wachlin, a descendant of the Oakley family, is a fifth-generation Fire Islander. In this photograph, he is standing next to a "family tree," an obscure Oakleyville tradition in which longtime families in the community have selected trees in this nearby grove, carving their names into them over a span of decades. (Photograph by author.)

Murray Barbash still lives in Dunewood, the community he cofounded over 50 years ago. Recalling the years of leadership with the Citizen's Committee for a Fire Island National Seashore, he says, "Certainly there have been disagreements, but I think there is an under-appreciation for all that has been accomplished. If it wasn't for the National Seashore there would be damn fewer Fire Island homeowners today." (Photograph by author.)

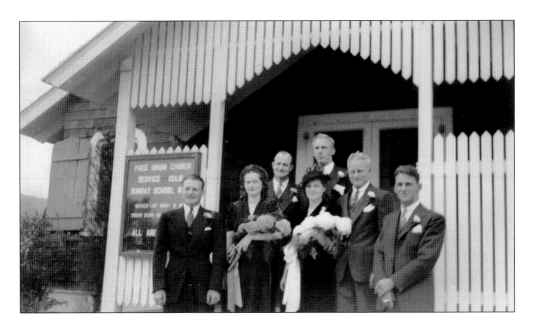

Childhood sweethearts Robert Stretch and Geraldine Pastorfield wed at the Free Union Church in 1939. The Stretch family built many of original houses for Ocean Beach developer John Wilbur in the early 1900s. The Pastorfield family came later, taking financial refuge on Fire Island prior to the Great Depression. Over 60 years later, inside the same chapel, their son Richard married Barbara Gelderman in 2002. With such continuity, one can take comfort in seeing the present firmly rooted to the past, and perhaps this remains Fire Island's greatest hope for the future. (Above, courtesy Dale Wycoff Collection; below, photograph by author.)

Jan Felshin and Edrie Ferdun have been together since they met in 1959 and have been summer residents of Cherry Grove since the early 1970s. On their 49th anniversary, they wed when same-sex marriage became legal in California. Upon returning to Fire Island on a midnight ferry, they were greeted by a crowd of friends who showered them with confetti and served champagne and cake on the ferry dock. "Every day here is a gift," says Ferdun, speaking of her beloved community. "It's like coming onto a stage and playing a part you love every day of your life." (Right, photograph by Jayne Baron Sherman; both, courtesy of Jan Felshin and Edrie Ferdun Collection.)

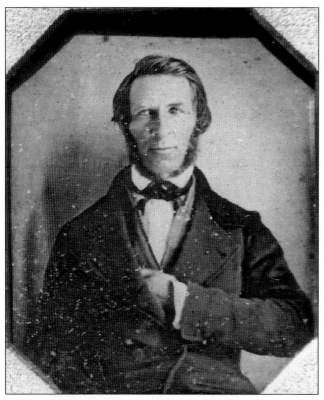

Early Fire Island Lighthouse keeper-turned-hotel proprietor Felix Dominy sits for a portrait in 1849. It would be another nine years before the current lighthouse was built. Below, his descendant W. Tyson Dominy holds the portrait of his great-grandfather in 1969. While almost one and a quarter centuries have passed between the two photographs being taken, the resemblance between the men remains very striking. The Dominy family was but one bloodline that came to the shores of Fire Island. Many others have followed, leaving their footprints in the sand and a legacy never to be entirely washed away by the waves. (Both, courtesy Russell X. Mayer Collection.)

BIBLIOGRAPHY

Caro, Robert A. *The Power Broker*. New York, NY: Alfred A. Knopf, Inc., 1974.

"Confined to the Scandia: Cholera Attacked no other Vessels Yesterday." *New York Times*. September 11, 1892.

"Fire Island to get a Boating Center." *New York Times*. October 2, 1960.

Grammatico, Michael. *1938 Hurricane–September 21, 1938*. Geocities.com. October 13, 2004.

Havemeyer, Harry W. *Fire Island's Surf Hotel*. Mattituck, NY: Amereon House, 2006.

Johnson, Madeleine C. *Fire Island: 1650s–1980s*. Point O'Woods, NY: Point O'Woods Historical Society, 1983. (4th Printing, 2004.)

Koppelman, Lee E., and Seth Forman. *The Fire Island National Seashore: A History*. Albany, NY: State University of New York Press, 2008.

Mooney, Captain Edwin J. *Ferries to Fire Island: 1856 to 2003*. North Babylon, NY: C.E.M., Inc., 2004.

Newton, Esther. *Cherry Grove, Fire Island*. Boston, MA: Beacon Press, 1993.

Tanski, Jay. *Long Island's Dynamic South Shore: A Primer on the Trends Shaping our Coast*. Stony Brook, NY. New York Sea Grant Extension Program, 2007.

Thoreau, Henry David. *Cape Cod*. Cambridge, MA: The Riverside Press, 1887.

www.fireislandlighthouse.com

www.lighthousefriends.com

INDEX

Atlantique, 39, 111
Babylon, 30, 34, 82
Bay Shore, 34, 41, 51, 53, 59
Citizen's Committee for a Fire Island National
 Seashore, 78, 79, 121
Cherry Grove, 30, 40, 44, 55, 56, 64, 66, 69, 71,
 105, 116, 119, 123
Clock, Selah, 35, 37, 41,
Corneille Estates, 37, 53, 99, 115
Davis Park, 6, 43, 52, 57, 64, 67, 76, 120
deer, 98, 99, 110
Dominy, Felix, 26, 53, 124
Dunewood, 6, 45, 52, 79, 121
Fair Harbor, 41, 63, 64, 70
FIA, see Fire Island Association
FIMP see Fire Island to Montauk Point Restoration
 Project
FINS see Fire Island National Seashore
Fire Island Association, 6, 78, 106, 107, 127
Fire Island Land Trust, 109
Fire Island Lighthouse, 15–18, 25, 26, 58, 70,
 90, 91, 118, 119, 124
Fire Island National Seashore, 9, 10, 45, 46, 62,
 78–82, 83–94, 95, 100, 102, 106, 107, 109, 110, 118,
 120
Fire Island Summer Club, 43, 112
Fire Island to Montauk Point Restoration Project
 103, 104, 106
Fire Island Pines, 44, 64, 66, 67, 109, 116, 117,
 119
Floyd Estate, William, 88, 89, 92
Fuller, Margaret, 17, 18
General Management Plan, 94, 107
GMP, see General Management Plan
Great Depression, 40–42, 122
Hurricane of 1938, 40, 41, 45, 58, 69–73, 95
Kismet, 8, 26, 42, 64, 67, 68

Lonleyville, 35, 41
Mastic, 13, 50, 75, 88
Moriches Inlet, 11, 72, 94, 104
Moses, Robert, 9, 10, 32, 53, 73, 76–82, 91,
 112
Native American, see Poospatuck
Oakleyville, 35, 121
Ocean Beach, 6, 36, 37, 50, 53, 54, 57, 64, 65, 71,
 74, 76, 78, 96, 97, 99, 103, 114, 119, 122
Ocean Bay Park, 42, 64,
Patchogue, 24, 43, 59, 84
Peconic Baykeeper, 108
Perkinson's, 32, 69
Pike Wilderness Area, Otis 46, 49, 79, 92
Point O'Woods, 2, 6, 12, 23, 34, 35, 40, 43, 51,
 57, 64, 94
Poospatuck tribe, 13
Robbins Rest, 41
rumrunners, 39, 59
Sailor's Haven, 84–86, 97
Sammis, David, see Surf Hotel
Saltaire, 6, 8, 33, 38, 55, 57, 64, 71, 73, 110
Sayville, 59, 84
Seaview, 37, 57, 78, 97, 115
Smith, Jeremiah, 9, 30
Smith, William "Tangier," 13, 14, 28, 75, 89
Surf Hotel, 9, 10, 14, 27–32, 36, 58, 62, 82
United States Lifesaving Service, 9, 19–25, 65
Watch Hill, 86
Water Island, 39, 108
World War I, 49, 50
World War II, 40, 41, 51, 56, 96
West Fire Island, 9, 10, 45
Women's National Relief Association, 22

About the Organization

Since 1955, the Fire Island Association has championed the interests and concerns of the homeowners of Fire Island and no other public interest, lobby, or agenda. This mission has put the association at the forefront of issues critical to the welfare of the island itself as well as to the people who live, vacation, or work there. The FIA also serves as a liaison to the complicated network of municipal, regional, state, and federal governments that serve the area. It strives to keep all Fire Islanders educated and informed as it addresses the quality of life issues that residents and other stakeholders face in this unique location. Through the FIA, what might otherwise be disparate and isolated communities have the opportunity to speak with a unified voice. Learn more by visiting the website, www.fireislandassociation.org, and kindly consider pledging your support.

Presidents of the Fire Island Association

Arthur Silsdorf 1961–1965
Charles Lowery 1965–1969
George Biderman 1969–1981
Norma Ervin 1981–1983
John Stearns 1983–1987
Gerard Stoddard 1987–2011
Suzanne Goldhirsch 2011–present

DISCOVER THOUSANDS OF LOCAL HISTORY BOOKS FEATURING MILLIONS OF VINTAGE IMAGES

Arcadia Publishing, the leading local history publisher in the United States, is committed to making history accessible and meaningful through publishing books that celebrate and preserve the heritage of America's people and places.

Find more books like this at
www.arcadiapublishing.com

Search for your hometown history, your old
stomping grounds, and even your favorite sports team.

Consistent with our mission to preserve history on a local level, this book was printed in South Carolina on American-made paper and manufactured entirely in the United States. Products carrying the accredited Forest Stewardship Council (FSC) label are printed on 100 percent FSC-certified paper.

MADE IN THE USA